Harmony
by Hand

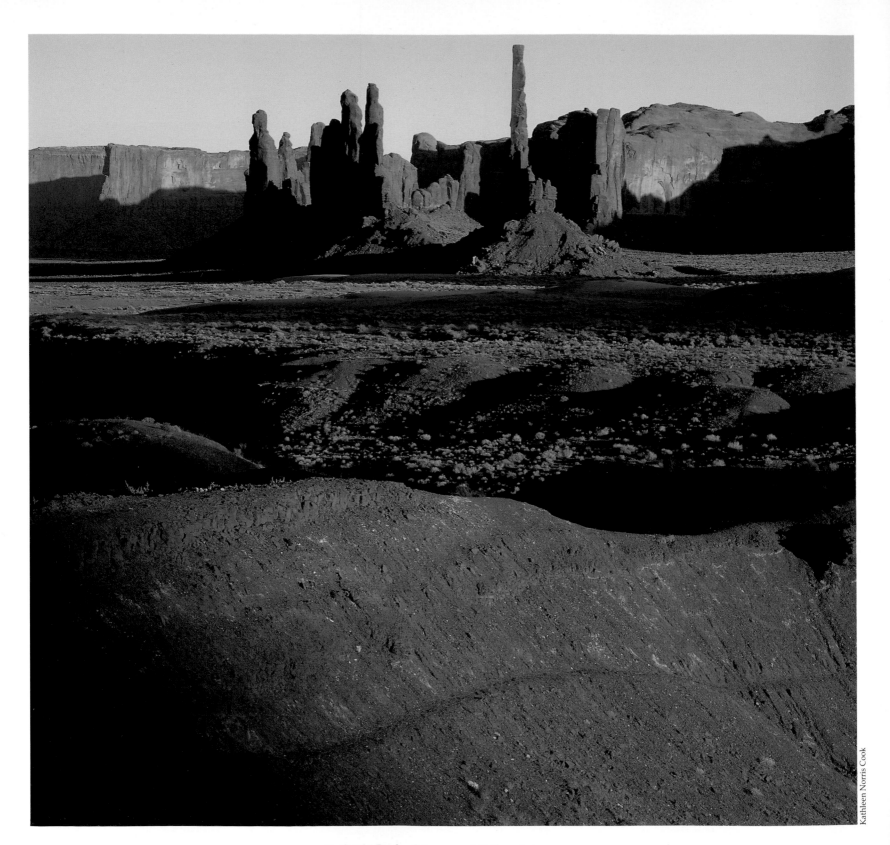

Ye Beichi Rocks, Monument Valley, Arizona

HARMONY BY HAND

ART OF THE
SOUTHWEST INDIANS

BASKETRY ✦ WEAVING ✦ POTTERY

Text by
Patrick Houlihan Jerold L. Collings
Sarah Nestor Jonathan Batkin
Design by McQuiston & Daughter

Chronicle Books, San Francisco

Acknowledgments

A spirited enthusiasm and abiding passion for artistic traditions of the Southwest is shared by many people who participated in this project. This sensitivity goes well beyond individual areas of expertise and yields a generosity that is truly exceptional.

The following have helped make this book possible in various ways, and for their cooperation and continued support we are deeply grateful.

For patience and proficiency, the authors cannot be thanked enough. Patrick Houlihan's suggestions have greatly benefited this book editorially, and Jerry Collings' kindness and good nature transformed otherwise tedious tasks into pleasant ones.

Grace Johnson, Assistant Curator at the San Diego Museum of Man, deserves special thanks for her tireless yet cheerful efforts in response to our numerous requests. Also at the Museum of Man, Kenneth Hedges has given support crucial to the success of this project.

The high-quality photography of Carina Schoening and Gordon Menzie of Click Studios, San Diego and Jerry Jacka of Phoenix has given the exquisite artwork another beautiful dimension. Their participation was invaluable and is sincerely appreciated.

We thank Jane Kepp at the School of American Research for her advice on the project, and also at SAR, many thanks to Marianne Kocks. Claudine Scoville, Craig Klyber, Cathy Burton and others at the Southwest Museum, and Mary Graham at the Heard Museum have all helped considerably. Thanks also to the Taylor Museum for their generosity.

For giving the idea for this book a chance, we are grateful to Jack Jensen and David Barich of Chronicle Books, and appreciate the support Chronicle has given us.

Many have steered us in the right direction at critical moments, or just smiled at the right time; among them we thank Dan Murphy, Tim Priehs, Dick Howard, Tim Wedel, and Bill LeBlond. And to Pat McQuiston: Thanks for putting up with us.

Finally, many aspects of this book have been influenced by the phenomenal work of Kate Peck Kent. Though not directly involved in this project, she is nonetheless very much a part of it, and we express our admiration and appreciation.

Produced and designed by McQuiston & Daughter, Del Mar, California; Edited by Frankie Wright; Composition by Thompson Type, San Diego; Printed in Japan by Dai Nippon Printing Co., through Interprint, San Francisco

Library of Congress Cataloging in Publication Data:
Harmony by hand.
 Bibliography: p.
 Includes index.
 1. Indians of North America—Southwest, New—Art.
I. Houlihan, Patrick T.
E78.S7H26 1987 745'.08997078 87-6321
ISBN: 0-87701-426-4 Paper
ISBN: 0-87701-455-8 Cloth
10 9 8 7 6 5 4 3 2 1

Chronicle Books, One Hallidie Plaza
San Francisco, California 94102

Distributed in Canada by
Raincoast Books, 112 East Third Avenue
Vancouver, British Columbia V5T 1C8

CONTENTS

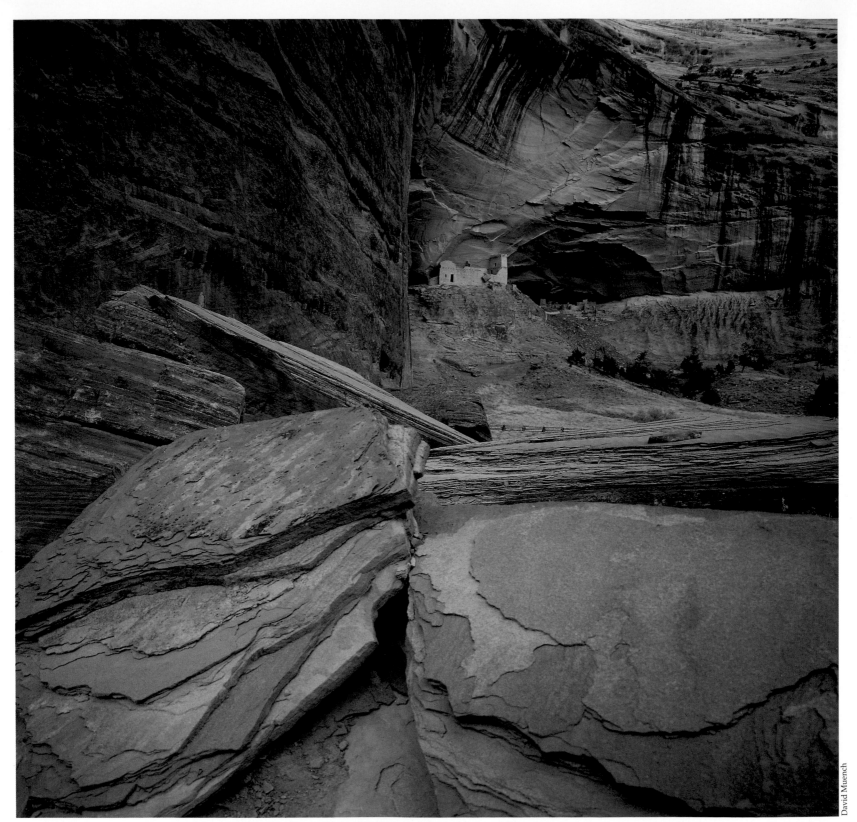

Mummy House Ruin, Canyon de Chelly National Monument, Arizona

WHERE
LIFEWAYS
ENDURE

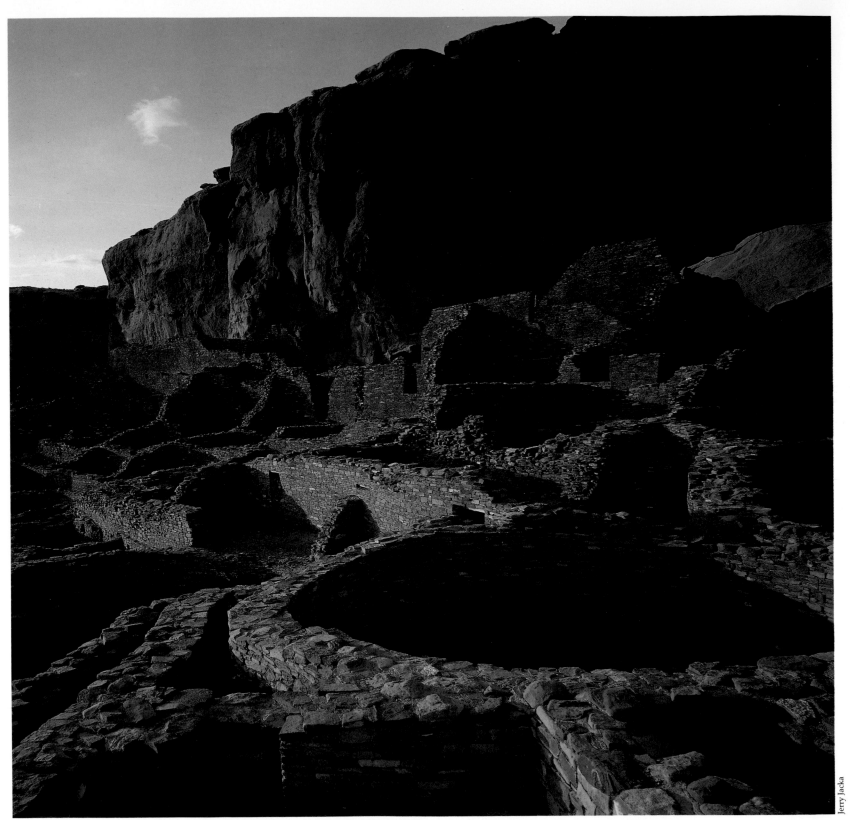

Pueblo Bonito, Chaco Culture Historical Park, New Mexico; (*facing page*) Anasazi potsherds

WHERE LIFEWAYS ENDURE

BY PATRICK HOULIHAN

The Southwest is a place where landscapes and lifeways converge; one's horizon line is limited only by one's understanding of it. For the native people of the Southwest, the land itself provides the most obvious and enduring evidence of tribal origins by connecting their past and present. Areas traditionally inhabited by the Southwestern tribes, whether mesa tops or river valleys, are, for most of these tribes, the same areas where their ancestors lived, and where their supernatural beings continue to live. Prominent landforms and features of the sky are imbued with spiritual and mythological significance.

In their sense of place the Southwest's Indian people have their continuing identity, and this identification of people and the land is expressed in what is made and used, worn and worshipped. Their heritage includes artistic traditions that have evolved from artifact to art, three of which are featured in this book—basketry, textiles, and pottery. Each tradition has come forward from prehistoric times to today. Each begins with an utilitarian purpose, primarily as a container or as clothing, which in time has seen an elaboration in design beyond what was merely functional. Each has been influenced by the environments, both physical and cultural, in which these people have struggled to sustain life.

Charles Fletcher Lummis, a late nineteenth century California-based writer of Indian and Hispanic cultures, applied the term

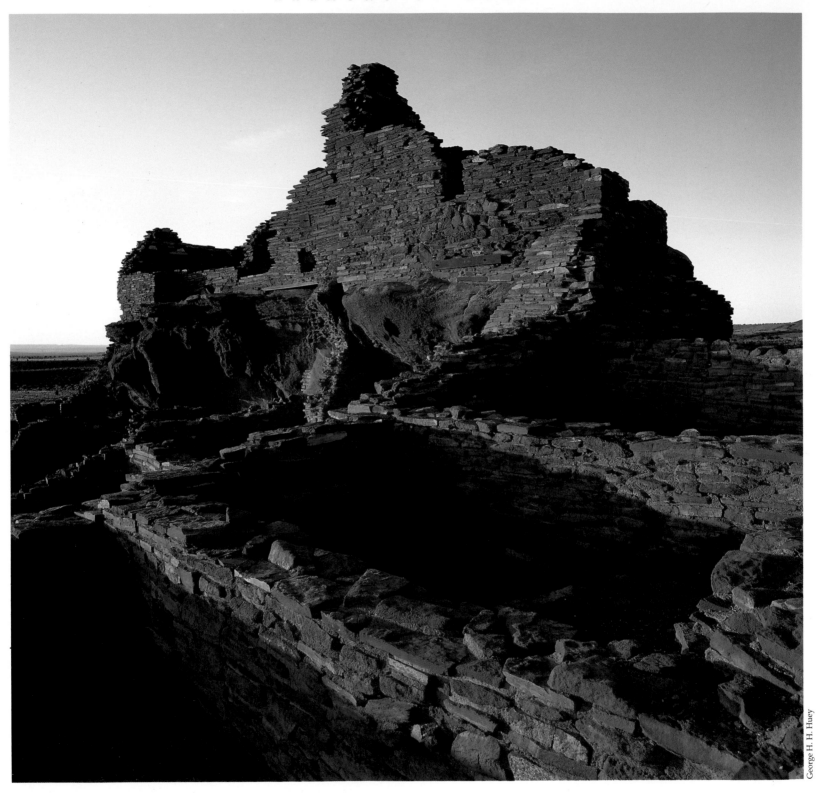

George H. H. Huey

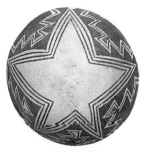

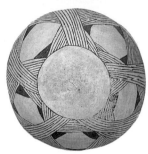

"Southwest" to the region as we know it today. Earlier, Spanish-speaking scholars in Mexico and Spain called it "the northwest frontier of New Spain." This seeming directional contradiction—southwest versus northwest—is an important one, for many of the region's cultural achievements originated in present-day Mexico or Central America and then moved north, particularly pottery manufacture, certain techniques of basketry construction, and the cultivation and weaving technology of cotton for textiles. However quite beyond these material aspects, cultural continuities from Mesoamerica to the Southwest are so strong that separating the two regions seems merely a matter of convenience.

When anthropologists, historians, and geographers discuss the Southwest they are usually careful to distinguish between the American Southwest and the Greater Southwest. The American Southwest, having modern-day political boundaries, consists of Arizona, New Mexico, and the southern portions of Utah and Colorado. The Greater Southwest is determined by cultural factors irrespective of national boundaries and covers the American Southwest, as well as the four Mexican states of Sonora, Chihuahua, Sinaloa, and Durango.

The Greater Southwest is one of several large divisions of the North American land mass designated as *culture areas*—geographical regions within which the various early cultures tend to be similar, in part, by virtue of parallel survival strategies and by the effect of cultural contact among regional groups. The Southwest discussed in this book is intended as a cultural unit, but one limited by space demands to that portion of the culture area north of Mexico.

The Southwest culture area has three principal physiographic features: deserts, mountains, and plateaus. Each of these macroenvironments possesses diversity within itself. Climate, water sources, elevation, and geology can vary dramatically within short distances. For the people who lived on these lands, each environment challenged habitation, sometimes forcing radical adaptation when natural phenomena, extreme or subtle, created a precarious, if not inhospitable environment. As a result, the life-sustaining strategies—how people clothe

Ceramics largely replaced basketry for cooking, storage, and ceremonial use around A.D. 200. Not all prehistoric vessels were painted; those that were possibly played an important role in trade. (Top: Black-on-white Anasazi bowl; bottom: Snowflake black-on-white Anasazi bowl with Puerco-style design, A.D. 950–1200.) Opposite: Wupatki Ruin stands alongside the Little Colorado River just north of the San Francisco Mountains. Once a flourishing cultural crossroads where the people of Wupatki traded with the Hohokam and Anasazi, the area was abandoned by the mid-thirteenth century.

and shelter themselves, how they obtain food and water—differed for those who lived in these regions. And as changes in climate, vegetation, and animal life evolved, differences in these strategies became even more pronounced.

The deserts of the Southwest, the Sonoran (southern Arizona and Sonora) and the comparatively colder Chihuahuan (southern New Mexico and Chihuahua), are separated by a narrow strip of mountains that are the southern Rocky Mountains in the United States and the Sierra Madre Occidentals in Mexico. Though representing the severest test for habitation, desert expanses are not without life. Cacti and other plants, and a surprising variety of animals, have adapted to high temperatures and little water. The deserts themselves vary in elevations below 3,500 feet and both are coursed by rivers: the Gila River and Salt River in the Sonoran Desert and the Rio Grande in the Chihuahuan Desert. Along these rivers and their tributaries, many cultures have flourished through history and prehistory.

North of these deserts, in an arch stretching from northwestern Arizona into southwestern New Mexico, is a high mountainous belt called the Mogollon Rim. Here elevations range from 4,000 to 10,000 feet. At higher elevations the Mogollon Rim supports large stands of pine, fir, and spruce. In lower canyons and stream bottoms a variety of deciduous trees thrive. Winter snow and seasonal rainfall collect during spring as runoff, which eventually flows to the major rivers that traverse the deserts.

Finally, to the north of these mountains is the Colorado Plateau, a profusion of relatively flat surfaces that range from 5,000 to 8,000 feet. Within these variable elevations are found bands of vegetation: sagebrush and grasslands at the lowest elevations; pinyon-juniper stands at intermediate elevations; and at the highest elevations, coniferous forests. The Plateau's highest mountains are the result of volcanic action, and several, such as the San Francisco Peaks near Flagstaff, Arizona, rise above 10,000 feet. These peaks, for example, are among those that have become fixed in the cosmology of Hopis and Navajos as the home for supernatural

11

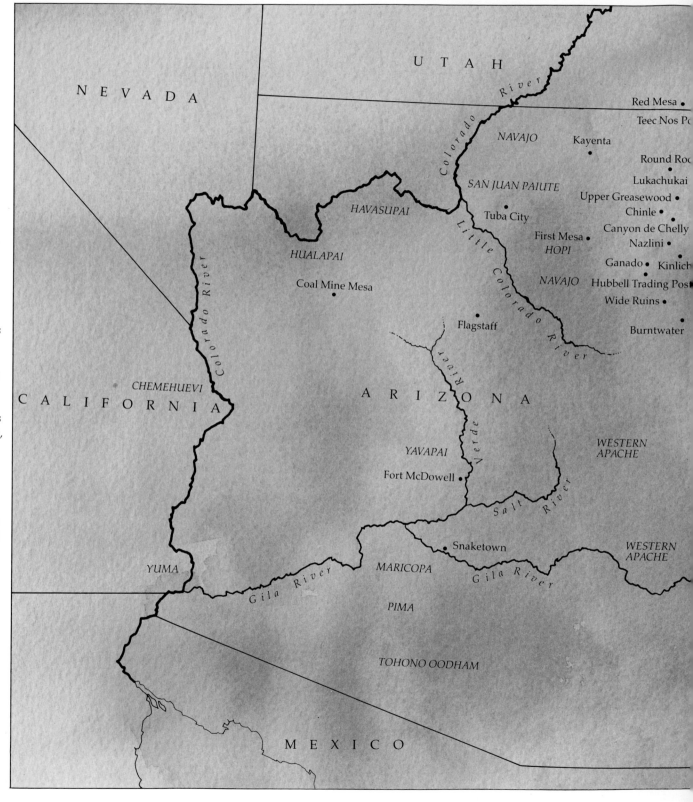

The Southwest sky is never distant. The piercing clarity of night gives way to morning light that textures the land, lifting color into intense hues. As shadows edge away from gnarled desert scrub or fade from rugged canyon walls, detail yields to the midday sky's pervasive blue brilliance. This is the sky, a still, pure blue, so closely identified with the region. Yet this world overhead is often imposing with thunderheads, lightning, or storms. It bears life-giving rains and maps the annual cycles. To the people, through time, who have struggled for survival on the arid lands below, the sky, with its daily and seasonal transformations, is an integral part of the natural realm. To them, the life of the sky and the life held in all things—mountains, rivers, rocks, plants, and animals—

12

NEVADA

UTAH

Colorado River

Red Mesa

Teec Nos Po

NAVAJO Kayenta

SAN JUAN PAIUTE Round Roc

HAVASUPAI Lukachukai

Little Colorado River Upper Greasewood

Tuba City Chinle

First Mesa Canyon de Chelly

HUALAPAI HOPI Nazlini

Ganado Kinlich

Coal Mine Mesa NAVAJO Hubbell Trading Pos

Wide Ruins

Flagstaff Burntwater

Colorado River

CHEMEHUEVI ARIZONA

CALIFORNIA

Verde River

YAVAPAI WESTERN
 APACHE
Fort McDowell

Salt River

Snaketown WESTERN
 APACHE
YUMA Gila River MARICOPA Gila River

PIMA

TOHONO OODHAM

MEXICO

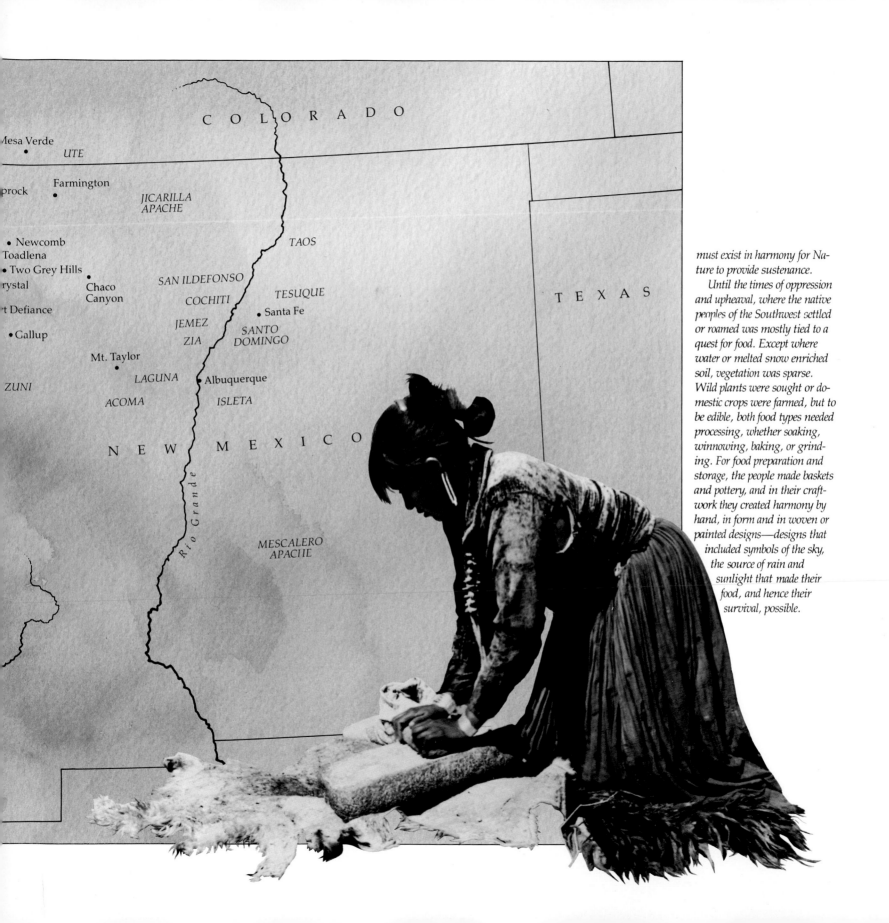

Mesa Verde

UTE

prock Farmington

JICARILLA
APACHE

Newcomb
Toadlena
Two Grey Hills
rystal Chaco SAN ILDEFONSO
 Canyon
t Defiance COCHITI TESUQUE

TAOS

Santa Fe

JEMEZ SANTO
ZIA DOMINGO

Gallup

Mt. Taylor

ZUNI LAGUNA Albuquerque

ACOMA ISLETA

NEW MEXICO

COLORADO

TEXAS

Rio Grande

MESCALERO
APACHE

must exist in harmony for Na-
ture to provide sustenance.
 Until the times of oppression
and upheaval, where the native
peoples of the Southwest settled
or roamed was mostly tied to a
quest for food. Except where
water or melted snow enriched
soil, vegetation was sparse.
Wild plants were sought or do-
mestic crops were farmed, but to
be edible, both food types needed
processing, whether soaking,
winnowing, baking, or grind-
ing. For food preparation and
storage, the people made baskets
and pottery, and in their craft-
work they created harmony by
hand, in form and in woven or
painted designs—designs that
 included symbols of the sky,
 the source of rain and
 sunlight that made their
 food, and hence their
 survival, possible.

13

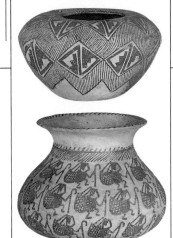

beings. Other elevated landforms rising abruptly from wide valleys are mesas, carved into their flat-top shapes by centuries of wind and water action. Erosive winds and water also caused the deep cutting of the Plateau's canyons, which include such landmarks as the Grand Canyon and Canyon de Chelly.

The entire Southwest is dominated by a general condition of aridity. However, from 10,000 B.C. to approximately 6000 B.C., the Southwest was a savannah-like environment, much wetter and its vegetation much more lush than it is today. Archaeologists have termed the culture of this era the Big Game Hunters, for at this time a number of large animals, now extinct, inhabited the region and were hunted by men for food and for their hides. These include mammoth, giant bison, camel, the horse, and the giant ground sloth.

Around 6000 B.C. the wet, lush environment of the Southwest began to change in favor of a climate similar to what is seen today. The large game animals disappeared, making the pursuit of smaller game—deer, antelope, and rabbits, as well as quail and wild turkey—important for survival. The search for wild food plants was also essential. These plants included the seeds of wild grasses, pinyon nuts, mesquite beans, agave stalks, and the fruit of various cacti.

For archaeologists and cultural historians, this is the beginning of the Archaic Period, which lasted about six thousand years. Stone tools and weapons used during this period have been recovered in considerable number, having withstood time and the elements. Additional items, such as animal skin and vegetal fiber clothing and containers, bone tools and ornaments, and vegetal (wood and grass) utensils are assumed to have existed .

Two particular artifacts give evidence of subsistence change for the peoples of Archaic Period: the *mano* and *metate* and the remains of baskets. Both the grinding tool and basket were necessary for the gathering, storage, and processing of plants, roots, seeds, and nuts for food. Utilitarian needs for containers and some clothing forms, such as woven sandals, focused increased attention on the technol-

Through their artistic traditions, the Southwest's native peoples have expressed their cultural identity. Pottery, despite its many forms and diversity in surface decoration, conformed to a group's established style. The two prehistoric vessels shown here display recognizable motifs. They may have been used or traded, or perhaps served ceremonial purposes. Opposite: Belief systems also support cultural identity. From ancient times, the kiva, an underground ceremonial chamber, has been central to Pueblo religious life. The ladder is said to represent the means of passage for the first people's emergence from the world below, their birth from Mother Earth.

ogies of basketry and weaving, thus preparing later generations for their manufacture and use. Furthermore the need for containers for storing, preparing, and serving these new foods anticipated the use of pottery, preconditioning its later acceptance.

By A.D. 200, archaeologists are able to distinguish three major cultures in the Southwest, at least two of which are thought to have evolved out of a more generalized Desert culture (2000 B.C.–A.D. 1). These archaeological cultures have come to be known as the Mogollon, the Hohokam, and the Anasazi. Each was localized at various points in time on one of the three macroenvironments, in the mountains, deserts, and plateau lands respectively. Frequently they are known only by specific sites: Anasazi by Mesa Verde and Chaco Canyon; Hohokam by Casa Grande and Snaketown; Mogollon by the Mimbres River Valley.

Notable differences in house types, religious structures, food storage systems, and artifact inventories are evident for these cultures. Many of these traits and especially agriculture came to the Southwest from Mexico. In each culture the utilitarian arts of basketry, textiles, and pottery were present, with known differences in manufacture and in painted or woven designs, as well as with assumed differences in ideology relating to them.

The ideological sphere offers the most difficulties for today's researchers when dealing with prehistoric artifacts and art. In prehistory, or the prehistoric period, no system of writing existed by which events or impressions could be recorded. Not until the arrival of Spanish Conquistadors in 1540 was the history of the Southwest documented as we know it. From 1540 on, the historic period, observations of Southwest cultures provide some evidence of their beliefs in written testimony. In addition, there are, of course, oral traditions passed through generations. Historic records show that clay, for example, had a spiritual dimension for the Puebloans in Clay Woman or Clay Mother. They made offerings to her when removing portions of her body (raw clay) from the earth. Basketry is frequently associated in the pueblos with ritual dances that occur at harvest time. The Spider Woman myth for the origin of

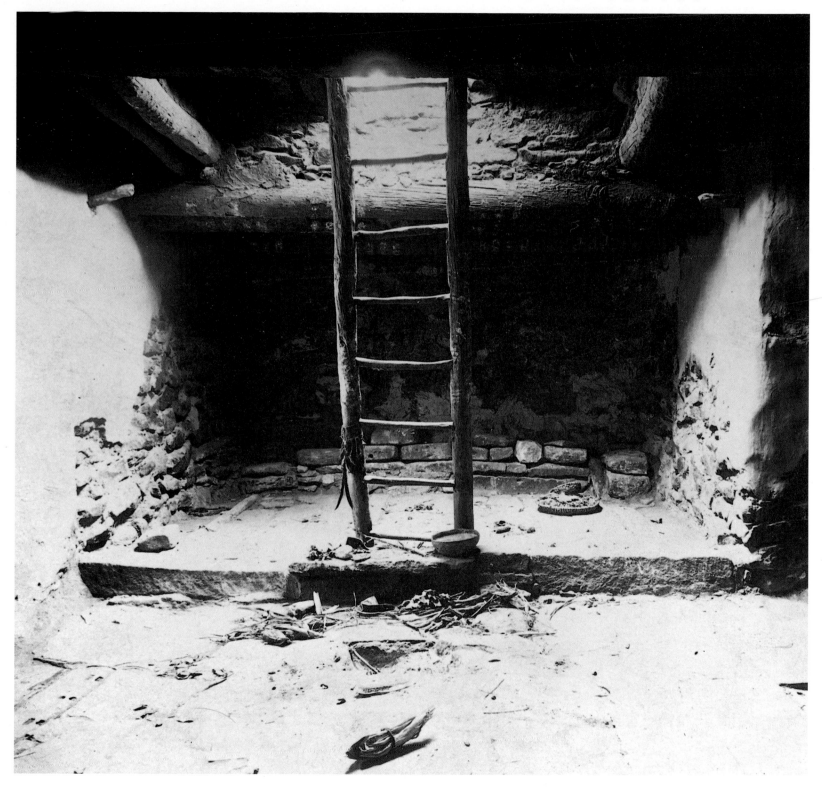

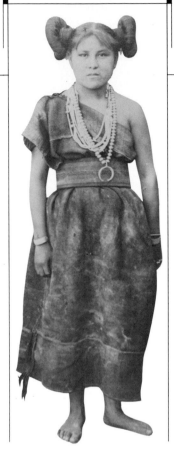

Navajo weaving is also well known, which although it relates to the weaving of woolen textiles, is nonetheless an indication that weaving had mythological and spiritual properties for the Navajo.

In any attempt to organize the historic tribes of the Southwest it is important to understand the criteria used by various people through time. For example, the early Spanish explorers differentiated the agricultural tribes they encountered on the basis of settlement patterns. Those they found living in compact villages in New Mexico and northern Arizona were called *pueblos* (after the Spanish word for town), whereas those living in scattered locations along rivers or irrigation canals in western and southern Arizona were called *rancheria* peoples, after the notion of isolated farmsteads or ranches. Non-agricultural tribes, living near and raiding both types of agricultural groups, were initially called *apaches* by the Spanish settlers, with no distinction made between Navajos and Apaches.

Unlike the Spanish explorers and settlers of the past, scholars today consider language a more consistent measure of relationships within and among Indian tribes of the Southwest. So, for example, the rancheria people, which the Spaniards encountered· along the Rio Colorado in western Arizona, are identified as Yuman-speakers; those living along the Gila and Salt rivers and their tributaries in southern and central Arizona are linguistically referred to as Piman-speakers. Navajos and Apaches are known to speak different branches of Athabaskan. And finally, the Pueblo peoples speak a language related to one of four major families: Tanoan (made up of Tewa, Tiwa, and Towa), Keresan, Zuni, and Hopi. By language spoken then, these are the native people of the American Southwest.

The Piman-speakers are generally considered to be descendants of the prehistoric Hohokam culture of the Sonoran Desert. This culture is usually divided into River and Desert Hohokam, representing different ecological niches and subsistence patterns. The River Hohokam (along the Gila, Salt, and their tributaries) were more dependent on agriculture than the hunting and gathering Desert Hohokam, who lived farther west in drier desert lands. Today

The "squash blossom" hairstyle signifies maidenhood for Hopi females. The large whorls are made by wrapping hair around a wooden bow and tying it underneath. In Hopi social organization, kinship is based on clan membership, and individuals belong to the clan of their mother. Married women own the houses and farmlands, and property is passed to married daughters. This unmarried Hopi was photographed in 1898 by George Wharton James.

Piman-speakers are subdivided as Pimas and Tohono Oodham (Papagos), each having separate reservations, and their tribal differences may in fact reflect the differences between the River and Desert Hohokam.

The Yuman-speakers living along the Rio Colorado practiced agriculture as well as seasonal hunting, gathering, and fishing, and have come to be known as Lowland Yumans. Among the best known of these groups are the Cocopah, the Quechan, and the Mohave. Other Yuman-speakers, the Upland Yumans, are found east and west of the Colorado River, and of those in Arizona, the Yavapai, Hualapai, and the Havasupai are perhaps the most recognized. Today the Hualapai (also spelled Walapai) and the Havasupai live along the Colorado River near Peach Springs, Arizona and in and about the Grand Canyon respectively.

The artifact inventory of the Yuma is significant when we consider their art forms. Among the more settled and agriculturally dependent Lowland Yumans, painted pottery is dominant, whereas for the Upland Yumans, it is basketry, especially coiled basketry. Most Havasupai, for example, acquired their pottery by trade with the Hopi and made very little of it themselves. Clearly the more transient hunters and gatherers had basketry as their major container; the more settled agriculturalists had pottery. And when basketry was made by the agricultural groups, undecorated plaited and wicker technologies were the tendency instead of coiled basketry with design elements.

The association between art forms and subsistence is also important to the discussion of Pueblo life. By growing corn, beans and squash, as well as cotton, both the Pueblo and rancheria people committed themselves to a need for containers and material for weaving. (Cotton seeds were also a food source.) Clay, the raw material of pottery, probably became familiar to them by virtue of their association with the soil and farming. And by being relatively stationary in their housing pattern, the problem of pottery's fragile nature was overcome.

The sixty or so pueblos the Spanish encountered are today less than two dozen in number. Those

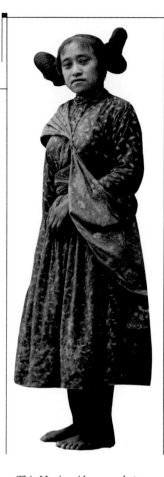

located in the west on the Colorado Plateau—the Hopi, Zuni, Acoma, and Laguna, for example—are called the Western or Plateau Pueblos. Those located to the east along the Rio Grande and its tributaries are called the Eastern Pueblos. All Pueblo people are descendants of the prehistoric Anasazi and Mogollon cultures.

Almost all of the Eastern Pueblos are situated on or near permanent water sources. As a result, agriculture here is much less precarious when compared to the Western Pueblos, where riverflow and rainfall are seasonal. In the early historic period the difference in water supply caused Spanish farmers to settle in the east and Spanish ranchers (raising sheep, goats, cattle, and horses) to settle more in the west.

This Spanish settlement pattern in turn affected the Pueblos, not only by the addition of domesticated animals to native farming and other subsistence activities, but also in the religious and artistic spheres of Indian life. The village-presence of Catholicism, for example, is much greater among Eastern Pueblos as is the Spanish influence on manufacture and design of textiles and pottery. A glance at the names of the pueblos as they are known today indicates that many Eastern Pueblos are named after the patron saint of the Catholic mission church established there by the early Spanish missionaries. None of the Western Pueblos are thus named.

Nowhere was there more friction among Indian groups in the Southwest than that between Athabaskan-speakers and all other Indians. Unlike the Yumans, Pimans, and Puebloans, the Athabaskans entered the Southwest late, sometime after the start of the thirteenth century. It is generally thought that over the next three hundred years, some Athabaskans adapted more to plateau environments while others adapted to the mountains. In time these adaptations and the ensuing linguistic isolation resulted in the two cultural groups we know today as the Navajo and the Apache. For each there are regional differences. For example, Navajos living in the Shonto Basin and in Canyon de Chelly practice more agriculture than others living in less-watered locations for whom pastoralism predominates. So too with Apaches. Anthropologists now recognize

This Hopi maiden was photographed by A. C. Vroman in 1901 at Sichomovi Pueblo at First Mesa. Close by Sichomovi is the village of Hano, which from a cultural viewpoint is far apart. The language and ceremonial practices at Hano differ from the Hopi's, reflecting Eastern Pueblo origins. Pueblo Indians are often discussed as a single group or as two major groups, Eastern and Western, but individual pueblos have generally held separate identities, evident in dress, ceremonies, and art styles.

at least six or seven Apache groups, two of which, the Lipan Apache and the Mescalero Apache, practiced seasonal buffalo hunting on the Great Plains.

When the forebearers of the historic Apache and Navajo first came to the Southwest from an area to the north, they practiced a subsistence based on hunting and gathering. After contact with the Pueblos they added some agricultural practices, and after contact with the Spaniards (as well as the Spanish-acculturated Pueblos) they required livestock. The Navajos integrated herding activities into their subsistence, and the Apache became more proficient in hunting on horseback. Both groups raided other Indians for food, livestock, and other booty. Raiding was both an economic activity and an avenue of social and political prestige for men; however, it eventually brought the Athabaskans into armed conflicts with the Spanish, Mexican, and American governments. In fairness it should be noted that Athabaskans were also preyed upon by the region's other residents and subjected to slavery.

The political history of the Southwest involves conflict. This history has seen Spain, then Mexico, and finally the United States seek to assert authority over Southwestern Indians, to say nothing of intertribal rivalries. However, against each of these national governments and their Indian policies, there was resistance: the sixteen-year Pueblo Revolt beginning in 1680, the most successful native revolt anywhere against the Spanish Empire; the Apache wars against the Mexican and United States governments; and the Navajo conflicts in the 1860s with the United States.

In all of this, it is the movement and transference of ideas that must be kept in sight. These ideas are reflected in the artistic traditions, showing the changes that occur when Indian groups are in contact with each other, with Spanish-speakers, or with English-speaking Americans, or further, when they must rapidly adapt to enforced cultural contact. Within the art forms, the heritage of harmony exists. Underlying the process of a tradition, and inherent in the result—a basket, weaving, or painted vessel—is the strong connection to the land, expressed in all its variations, expressing a continuing identity.

18

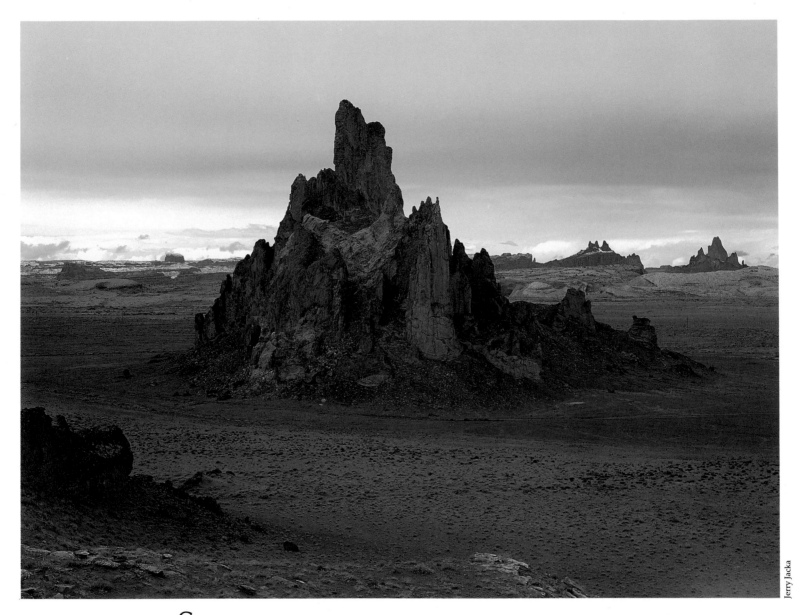

Jerry Jacka

*S*outhwestern terrain is dramatic in its variation, and whether harsh or hospitable, the land is held
sacred by the native peoples. The region's imposing landforms range from mazes of deeply carved
canyons to spectacular sandstone spires. Church Rock and other remnant cores of extinct volcanoes
haunt the desolate flatness near Kayenta, Arizona. Opposite: *The cliffs and spires of Monument
Valley have been shaped by internal and external forces over the millennia.*

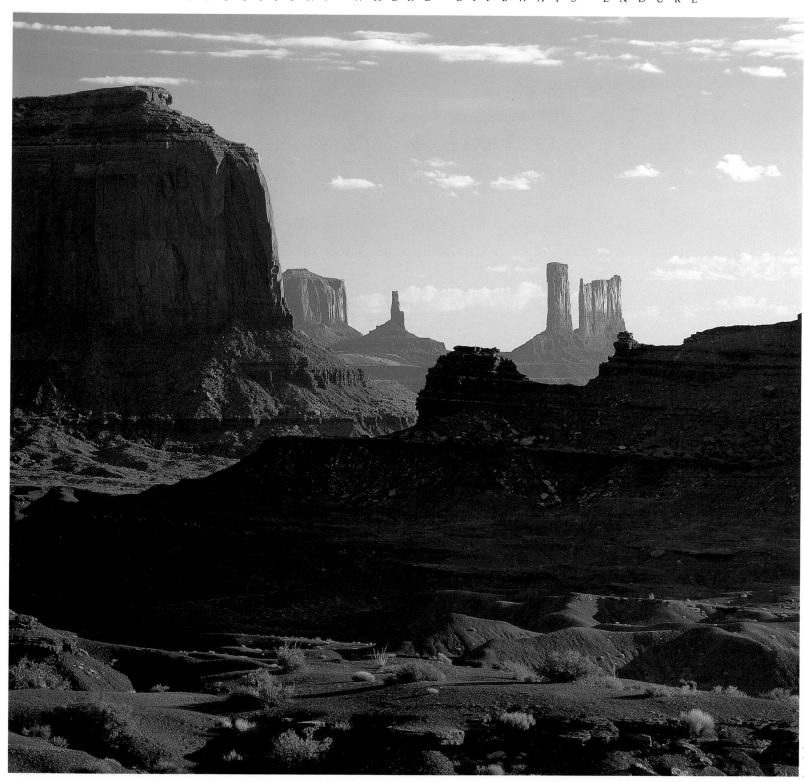

Jerry Jacka

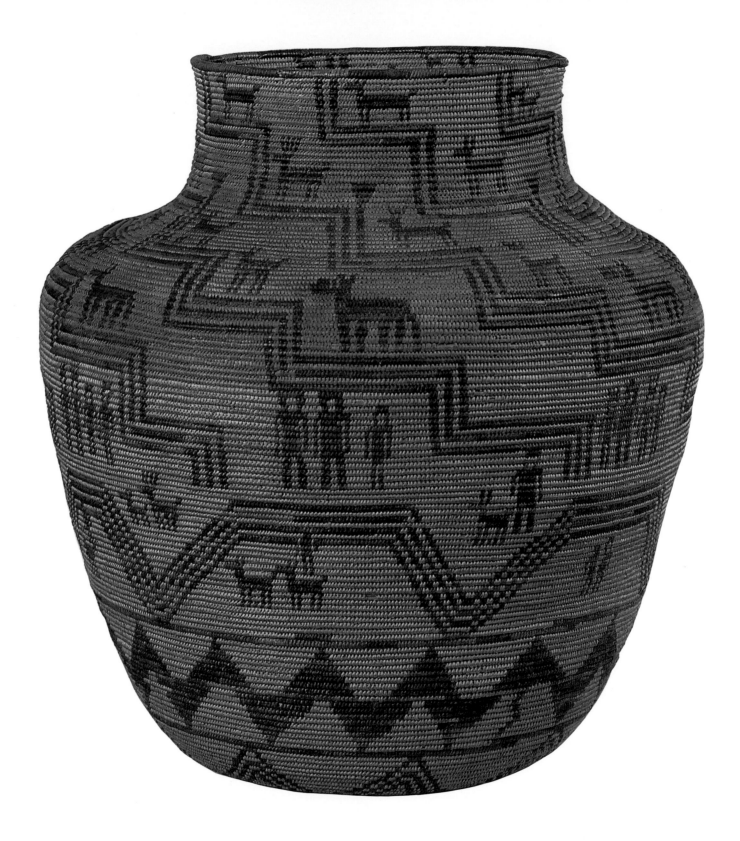

FROM

FOUNDATIONS

PAST

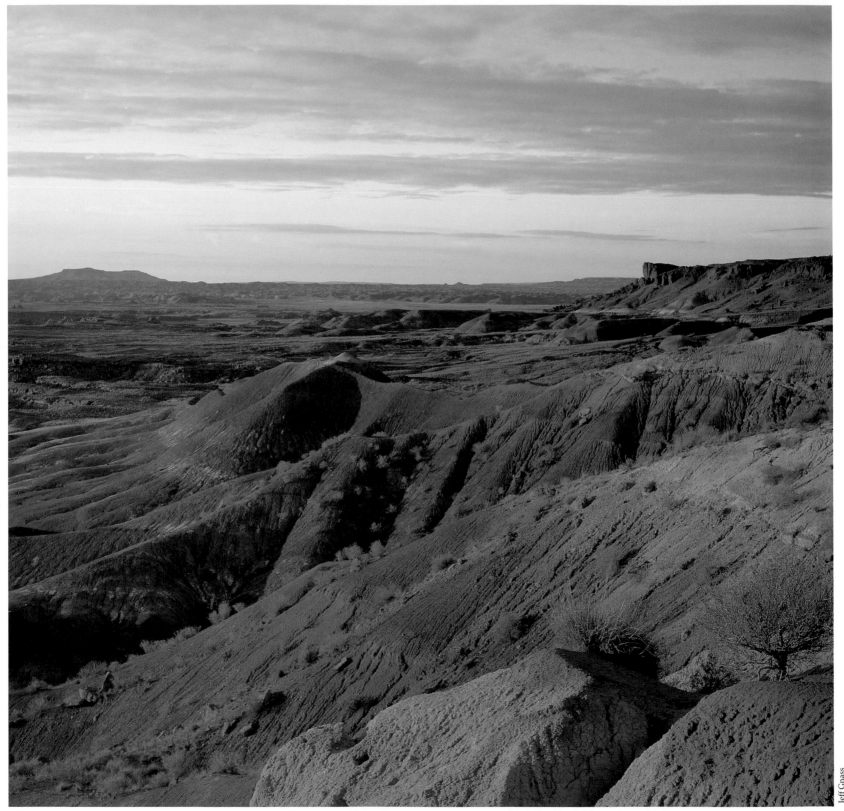

Jeff Gnass

Painted Desert, Petrified Forest National Park, Arizona; (*facing page*) Pueblo III winnowing tray

BASKETRY
FROM FOUNDATIONS PAST
BY JEROLD L. COLLINGS

With the exception of tool making, basketry is, apparently, the oldest of all craft arts. As such, basketry set the pace for artistic expression in many of the world's ancient cultures. In the Southwest, native Americans have been producing basketry in a variety of forms and with considerable technical diversity for at least the past eight thousand years. Rigid and semirigid containers, mats, and bags—all played an important role in their early attempts to cope with a strikingly beautiful but often harsh environment.

Most known examples of prehistoric basketry from the Southwest come from cave sites in the Four Corners area, once inhabited by the Anasazi. Most other major prehistoric cultures also produced basketry, but the open nature of the sites they left behind precluded the preservation of much more than carbonized fragments, impressions in clay, or occasional fragments of actual baskets. Artifacts that would otherwise disintegrate were preserved in dry deposits in the Four Corners cave sites, and so many baskets were found in the region that the name Basketmaker was given to the first three stages of Western Anasazi culture.

Archaeological evidence clearly establishes the prehistoric existence of three major subclasses of basketry: coiling, twining, and plaiting. In coiled weaves, moving vertical elements are sewn around stationary horizontal elements. The coiling variation that

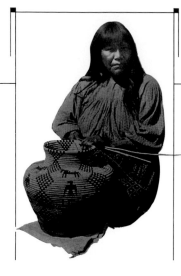

occurs most prominently in the Southwest is close-coiling, in which the stitches are so tightly placed that the foundation is not clearly visible. Many scholars insist that, technically speaking, coiling is not a "weaving" process at all, but is actually a type of sewing. The twining subclass includes weaves accomplished by passing moving horizontal elements (wefts) around stationary vertical elements (warps). And in plaited weaves, all elements are active and cross over and under each other without any engagement. Although these three basic techniques have been used extensively throughout the Southwest, and over long periods of time, coiling has emerged as the most important tradition in Southwest basketry. Not only does this method produce strong, durable, and very closely stitched basketry, but it offers the greatest potential for design development.

That basketry had considerable influence on the Anasazi ceramics that followed is evidenced by the discovery that some of the earliest Anasazi ceramic vessels were formed inside baskets. A ceramic vessel resulting from this technique retains the impression of the basket over which it was formed. Similarly, painted designs on much of the earliest Anasazi ceramics were derived from earlier basketry designs.

The peak of sophistication in the prehistoric development of design was reached during Basket-maker III (circa A.D. 500–700). Close-coiling of a rod and bundle type of foundation prevails, although other configurations were used. A particularly attractive and sophisticated design layout from this period involved the use of framing lines to mark the design field, which often covered half of a basket's total surface. The design field featured complex elements in red and black on a noncolored (tan) ground. The use of life forms or naturalistic motifs as design elements saw its highest development during prehistoric times in this phase.

Much less is known about the basketry of the Pueblo I and II phases (circa A.D. 700–1100). During these years dwellings were small surface structures usually built in the open. Both the size and location of these structures provided a poor environment for

Although this weaver has been identified as Apache, she may actually be Yavapai. The basket she is completing strongly favors a Yavapai identification. From long-term associations, the Yavapai adopted many Apache cultural traits, and baskets are similar for the two groups. In the past, many Yavapai baskets have been wrongly attributed as Apache, however, distinctions in artistic traits between the groups are now recognized.

preservation. Available evidence suggests that the basketry of these periods was somewhat less refined than that of the preceding period.

The large sheltered sites of Pueblo III times (circa A.D. 1100–1300) enhanced preservation of perishable materials. Artifacts from these sites show that although some degeneracy in decoration occurred as compared with the peak attainments in Basket-maker III, several Pueblo III baskets are technically the finest in all of prehistoric times. Stitch counts in close-coiled examples are sometimes as high as twenty-four per inch, and coils count as many as eight to the inch. Designs are generally in black only, although fairly complex integrated designs occur occasionally. The predominant style was to space out relatively simple, identical motifs.

Pueblo IV (circa A.D. 1300–1600) sites were more open and preserved artifacts are limited. From the few pieces recovered, weaving appears to have degenerated technically and artistically during this time. Coils and stitching are coarse and large, and designs are less attractive than in earlier periods.

The coming of the historic period in the mid-1500s to 1600 brought with it many changes in the lifeways of the Southwest Indians. Not all areas were affected equally or at the same time; however, every native population ultimately underwent cultural reassignment. Throughout much of this period (even into the early years of this century), Indian tradition was viewed as an obstacle to progress, and every available means was used to destroy it thoroughly and forever. The ever-practical white man was quick to accept the native methods of utilizing the region's natural resources, yet some considered native cultural achievements contemptible. What little survived of the native American's material culture was seen by many as mere remnants of a barbaric age.

Often, despite governmental efforts to the contrary, excellent basketry was produced throughout much of the reservation period. The breakdown of the traditional Indian economic system brought about a new need for cash. Basketry was almost entirely the work of Indian women, and these women soon learned that through the sale of their baskets to "outsiders" they could contribute signifi-

24

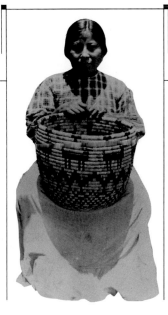

cantly to the family income. "For sale" baskets became a fertile ground for experimenting with new forms, designs, and uses. In a craft that had been extremely conservative for centuries, boldness and creativity were now rewarded. The result was that some of the most outlandish and some of the most superb basketry emerged from the first half of the reservation period.

The traditional basket weaver was a true folk artist. She created works that were always an inextricable part of the social, economic, and ceremonial activities of her society. She worked within a limited range of shapes and designs that had been collectively established by her society. Yet within these culturally imposed limitations, a high degree of individual achievement and seemingly endless variations were possible. Only an occasional, especially gifted individual would add her own contribution of talent or quality to the prevailing style. But from her, a new standard would be established, serving as a model for other weavers who, though less gifted, were nonetheless strongly motivated to put forth their best effort. The effect was cumulative and resulted in the creation of basketry that both technically and aesthetically rivals the best anywhere in the world.

To understand and appreciate the basketry produced in the past, as well as that produced in the Southwest at present, individual tribes should be considered—groups that have excelled in basketry and groups that are now actively producing.

Of the work produced by Southwestern tribes, perhaps the most recognizable basketry is Western Apache. Exactly when the Western Apache and their relatives, the Navajo, entered this area is not known, but by 1500 they inhabited areas from northwest Texas to central Arizona. Much of what we now think of as Apache culture, including basket making, was probably derived from early interaction with the indigenous Pueblo peoples. However, after the Spanish introduced the horse in the mid-sixteenth century, Apaches became notorious raiders. From their mountain strongholds, they made frequent forays among the Pimans and Puebloans, and occasionally pillaged villages in the Mexican

A Second Mesa weaver, circa 1930–1940, was photographed as she neared completion of a large basket that probably went to a trading post. Hopi weavers, and weavers of other Southwestern groups, were generally limited to using the weaving materials of their immediate environment, materials that are more scarce today. They were also limited to the constraints of the craft—a large basket, for example, may have taken months to create.

states of Sonora and Chihuahua. By the time the United States acquired Arizona as a result of the war with Mexico, the Apache had developed a "raiding economy." During the 1870s and 1880s, they were engaged in almost constant warfare with U.S. military forces, but by 1890, nearly all were peacefully settled on reservations in Arizona.

Because of their roving life, the Apache had few possessions. They did not weave blankets and produced only a small amount of rather crude pottery that was strictly utilitarian. Their arts and crafts were mainly limited to the dressing of buckskin and to basketry.

Although they practiced both twining and close-coiling, it is with the latter technique that the Western Apache truly excelled. This technique allows much greater freedom in the creation of design. From a purely technical standpoint, the finer the coiling and stitching, the less restrictive are the design possibilities. Close-coiled shallow bowls and olla shapes were common forms. Bowls were typically two to four inches deep and twelve to sixteen inches across, a size range suited to such household uses as mixing, winnowing, parching, serving, and temporary storage. Around the turn of the century and later, however, outside demand inspired the production of much larger baskets. Shallow bowls ranging from twenty to thirty inches in diameter, often of superior workmanship, are known from this period. And olla sizes tended to be quite large, some between fifteen and twenty-four inches in height. Larger and smaller examples are not uncommon. Ollas required a great deal of time to construct (often a year or more) and demanded a high level of technical competence.

Today, as in the past, both the bowls and coiled ollas are constructed of willow or cottonwood. These materials create light-colored backgrounds. Devil's claw is used for black designs. The three rods, usually willow, are arranged two on the bottom and one on top and form the foundation about which the stitches are sewn. A reddish-brown material prepared from yucca root (*Yucca baccata*) is used occasionally and in some instances with spectacular results. This usage seems to be a late development

25

26

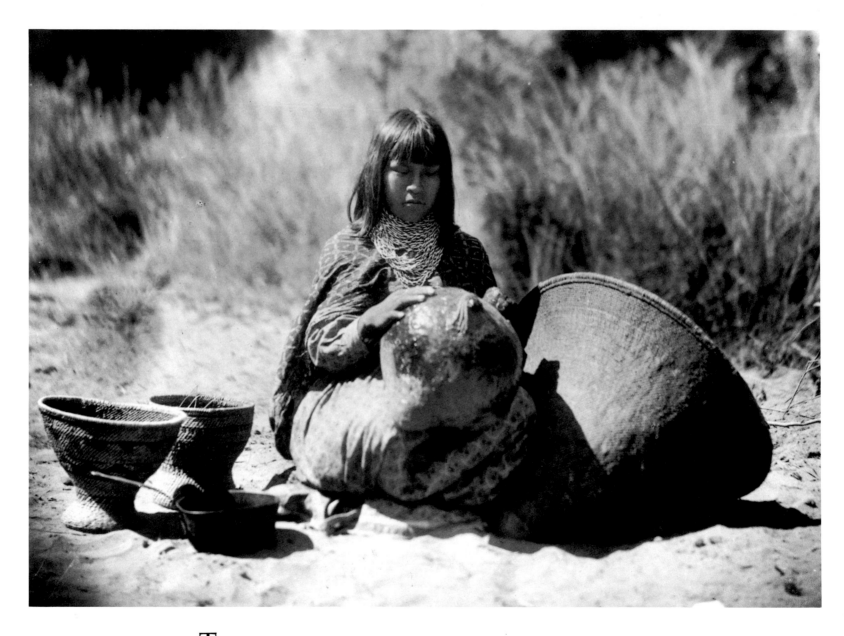

This young Havasupai weaver is applying pinyon gum to a basketry water bottle. The large conical twined basket is for carrying. Both were made for native use, whereas the two "compotes" at left were for sale to non-Indians. Opposite: Willard J. Chamberlain photographed this Havasupai weaver around 1912 in front of her home at Cataract Canyon, Arizona.

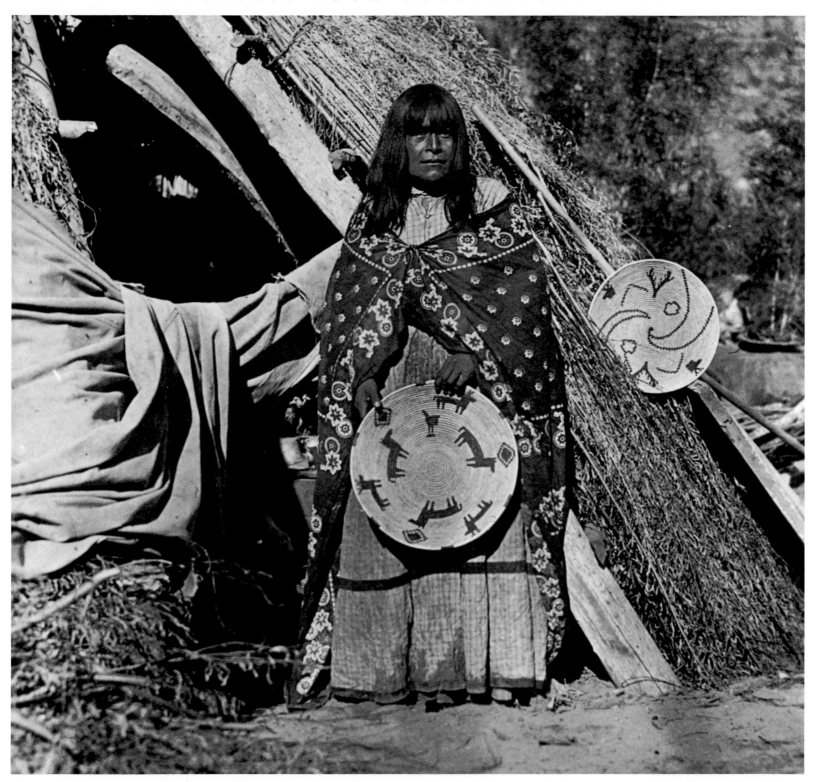

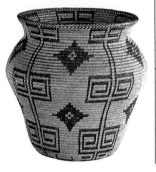

(probably post-1900) and judging from the relative scarcity of existing polychrome specimens, it seems never to have met with great favor among the weavers. Anyone who has ever dug the root, prepared it and worked with it, would certainly understand any reluctance on the part of Apache women to use this material in any but the most sparing manner.

Basketry designs are as varied as the land these people roamed. They range from extremely simple, static motifs to complex arrangements in which a rapid whirling motion is conveyed. Since the very latter part of the nineteenth century, Western Apache weavers have been especially fond of naturalistic motifs. Men, women, horses, deer, dogs, and birds are commonly used, but even exotic circus animals have found their much altered likenesses cleverly adapted to conform to Apache aesthetics, and to the technical limitations of three-rod coiling. Such motifs are often used to fill space within or in conjunction with geometric design elements. Occasionally however, a basket is seen in which a more or less random arrangement of these figures constitutes the sole ornamentation. If these designs ever had any significance beyond ornamentation, it has been lost. When asked to interpret the meaning of basket designs, a weaver might reply, "They make the basket look pretty," adding that she uses the designs "because the old people used them."

In addition to finely coiled baskets, the Western Apache also make two types of utility baskets in the twining technique—carrying baskets and water jars. Carrying baskets are commonly referred to as burden baskets and are essentially a conical shape with a rounded bottom. Most are twelve to fifteen inches in height. Apache women once used burden baskets to carry wood, wild foods, and other supplies. Smaller ones were made to be given to girls. Burden basket designs tend to be limited to simple horizontal bands usually executed in black and red. The black is devil's claw and the red is most often obtained by dying some of the weft material or by painting the design on the completed basket. It is further decorated with buckskin fringe, on which beads or tin cones are sometimes attached.

Originally, strength and durability were the pri-

A coiled basket, in which a foundation is tightly encircled by a sewing element that also pierces the previously sewn coil, is built row by row. This form of weaving allows the incorporation of striking designs, because sewing threads can be changed at will for contrast and color. When the desired shape and size has been achieved, the weaver finishes the basket. Finishes vary according to a group's tradition. This basket is finished with a false braided rim, a stitch with a herringbone design.

mary qualities sought in the construction of twined water bottles. They are mostly undecorated and roughly made. The material used varies from area to area, but willow, sumac, and squawberry are the most common. Ground juniper leaves and red ochre are rubbed into the fabric, and the basket is then made waterproof by smearing melted pinyon pitch over the entire surface. While sizes and shapes vary a great deal, nearly all water jars have a fairly wide mouth and a flaring neck.

Now that most food is purchased at a grocery store and carried home in paper bags in the back of a pickup truck, and because water can be stored in plastic containers, the principal reason for making baskets is to supplement cash income. As a result, the fine, close-coiled baskets, which often required months to weave, have been discontinued for the most part in favor of more quickly made twined baskets. Carrying baskets and water bottles are still produced on Apache reservations, but they too reflect the changing times. Some contemporary burden baskets are much coarser in weave and are generally made of rougher materials than the traditional baskets. And they come in artificially large and small sizes. The native tanned deerskin has been replaced by commercially tanned leather. Even the "tin cones" are now often aluminum and have lost much of the cheerful tinkle that used to accompany movement. The water bottle is rougher than ever. Red barn paint has, in some instances, replaced the red ochre, and the coating of pinyon pitch is often omitted. Nevertheless, some of the better contemporary examples are pleasing and find a ready market with both collectors and decorators.

The Yavapai have been called by so many different names that their very identity has been obscured. The Yavapai are members of the Yuman linguistic family, but they have long been associated with the Athabaskan-speaking Apache. They adopted many Apache cultural traits and even joined forces with them to raid the Walapai, Havasupai, Maricopa, and Pima. As a result they were often referred to as the Yuma-Apache, Mohave-Apache, Yavapai-Apache, or perhaps most often, simply Apache.

28

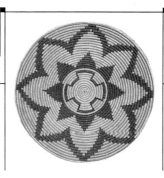

Absence of a black start (center) and a black rim distinguish this Havasupai basket from otherwise similar Apache or Yavapai weaves. This shallow bowl was purchased in the early 1960s from the weaver Minnie Marshall of Supai village, Arizona. It measures nearly thirteen inches in diameter. (Havasupai basketry is discussed on page 32.)

The Yavapai were historically divided into three subtribes, the Northeastern, the Southeastern, and the Western Yavapai. They ranged over a territory about twenty thousand square miles (from central Arizona west to the Colorado River), yet they probably never numbered more than fifteen hundred. They subsisted primarily by hunting and gathering, and thus were forced to migrate seasonally.

Yavapai close-coiled baskets were so similar in technique, material, and design to those of the Western Apache that little or no distinction was made between the work of the two tribes. This similarity is probably due to Yavapai confinement on the San Carlos Apache Reservation between 1875 and 1900. Determining who influenced whom, and to what extent, during this period is difficult. For example, the sheer numerical advantage of the Western Apache would be a strong argument in favor of that group's dominance, but baskets now recognized as very distinctly Yavapai in design were collected at Fort McDowell in the first decade after the Yavapai returned there in 1900. This would suggest that the Yavapai had succeeded in retaining at least some degree of artistic independence throughout their period of confinement. It is conceivable that they had some influence on the basketry of the Apache—Southwestern Athabaskans have been known as great cultural borrowers.

One design layout that is characteristically Yavapai consists of concentric, expanding stars (commonly five to seven points) that form several bands of opposing areas of light and dark in which alternate positive and negative figures appear. Ironically, this particular design layout is perhaps the one most eagerly sought by unknowing collectors as an example of "classic" Apache basketry.

Few Yavapai baskets are being made today. The small number of experienced weavers still at Fort McDowell are attempting to keep the tradition alive, but with marginal success. An occasional basket is also produced in the middle Verde and Prescott areas.

In native times the Pima referred to themselves by a term meaning the River People. They subsisted by irrigation farming and lived in permanent villages along the Gila and Salt rivers in southern Arizona.

During the latter half of the nineteenth century, the Pima were subjected to the worst influences of Anglo civilization: The Gila River was diverted upstream for non-Indian use, and as a result the once-prosperous Pimas were reduced to poverty and starvation. By 1900 little remained of the traditional Pima culture. Pima basketry may have survived this adverse period because, though no longer culturally important, it became a source of cash income.

Pima basket weavers are best known for their beautifully decorated, close-coiled bowls. These baskets range from twelve to twenty-four inches in diameter and from three to eight inches in depth. Large, deep bowls were primarily used for carrying. The loaded basket was balanced on the head and carried without support from the hands. Smaller bowls were used for preparing and serving food.

The light-colored sewing material is normally willow, although cottonwood is sometimes used. Black comes from the seedpod of devil's claw (*Martynia*). The Pimas cultivated a variety that has very long seedpods, often twelve inches or more, with white seeds. Most other Southwestern tribes use a wild variety that has black seeds and pods that are six inches or less in length. The development of this superior variety may explain the much heavier use of black in Piman design. Traditional Pima and Tohono Oodham (Papago) baskets nearly always have a relatively large black circle for the center and a black rim finish. The foundation is a bundle of finely split cattail (*Typha angustifolia*) stems. Occasionally a rust or pinkish tint is seen in Pima designs. Both are dyes, and tend to fade badly if exposed to sunlight.

Pima basketry designs are predominantly geometric, although both stylized and representational designs are also used. Pima weavers exhibited a genius for creating endless variations of a basic design theme.

Most Pima weavers tended to be conservative and adhered fairly strictly to tribally prescribed designs and forms, but an occasional weaver broke with tradition and created basketry that was totally original in design concept. This was especially true after the turn of the century when in addition to the baskets

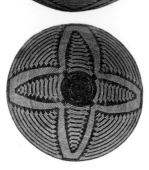

being made for native use, the Pima began making baskets to sell to outsiders. A proliferation of new shapes appeared. Among the hottest selling items were napkin rings, wastepaper baskets, and superb miniatures. This era was cut short by the ever-increasing availability of off-reservation agricultural work. During the thirties and forties many of the younger women were lured from basketry to farm labor where they could make a much higher daily wage. (Often, after having spent weeks or even months creating a basket, a weaver was offered no more for it than a sum equal to a few days' wages for picking cotton.) This newfound prosperity was rather short-lived. Mechanical harvesting equipment was soon introduced and, due to the resulting unemployment, basketry once again experienced a brief revival.

Today there are very few Pima weavers. Most live on the Gila River Reservation, but an occasional basket is produced at the Salt River Reservation as well. The quality of work remains amazingly high, and traditional forms still predominate. Recent innovation in design combined with superb craftsmanship have resulted in some contemporary work that rivals the best work of the past.

The Tohono Oodham (formerly Papago) are the Desert People who live in extreme southern Arizona and are basically the same people as the Pima. The cultural differences between the two tribes are largely the result of adaptation to environmental differences. Since the Tohono Oodham area was without rivers or permanent streams, these people were unable to farm as intensively as the Pima. They were forced to rely more on hunting and gathering and had to move about seasonally in search of water.

Traditionally, Tohono Oodham close-coiled basketry was very similar to that of the Pima. Some characteristics are more often associated with the Tohono Oodham, but there is perhaps as much variation in materials, technique, and design within the Tohono Oodham area as there is between the Tohono Oodham and Pima groups as a whole. Tohono Oodham baskets tend to have thicker walls, broader bases, larger masses of dark in the design, and bear grass (*Nolina*) foundations. Some thick-walled To-

Pima weavers refer to this motif as the "star." A relatively shallow form and the use of only two rows of white between the black bars strongly suggest that this basket was made in the 1940s. The false braided rim is typical. Opposite: *From arid lands, basket weavers collected the various materials they needed to produce the foundations and designs for their baskets. Shown here is a view of the Painted Desert in eastern Arizona.*

hono Oodham bowls are so tightly woven they are watertight. Pima baskets generally are more flexible, have more active and complex designs, and show superior craftsmanship. Plaited basketry was made in earlier years by both Tohono Oodham and Pima weavers.

Sometime around 1900 the Tohono Oodham began to substitute yucca for willow, which was much more scarce and had to be acquired by trade. Yucca, however, was used only in those baskets intended for sale to outsiders; willow baskets were still made for native use. This use of yucca marked the beginning of what was to become the almost complete commercialization of Tohono Oodham basketry. Soon new forms, new designs, and quicker weaving techniques appeared. These changes proved to be extremely popular with the non-Indian buyers whose main interest was the acquisition of an inexpensive souvenir.

At the present time Tohono Oodham weavers number in the hundreds and produce most of the Indian baskets seen in the trading posts and shops in the Southwest. Much of this work is quite coarse and rather hastily made, but a few superior weavers are contributing a limited quantity of high-quality basketry. Split-stitch weaves seem to be the most popular at present. The white yucca stitches are widely spaced, leaving much of the pale green bear grass foundation exposed. Subtle patterns can be created by careful placement of the stitches.

Closely stitched coiled baskets of sun-bleached white yucca are also made with designs executed in one or more colors. Baskets of this type are the high point of modern Papago weaving. Devil's claw provides the black; green and yellow are obtained from narrowleaf yucca. The root of the same plant provides a dark red-brown that is used occasionally. After the completion of each coil, the weaver pounds it flat with a hammer or smooth stone, producing the characteristic flat walls.

The Hopi are the only Southwestern Indians who today produce coiled basketry that is technically superior to their work a hundred years ago. The Hopi have clung tenaciously to their native culture, and basketry has retained at least a portion of its former

30

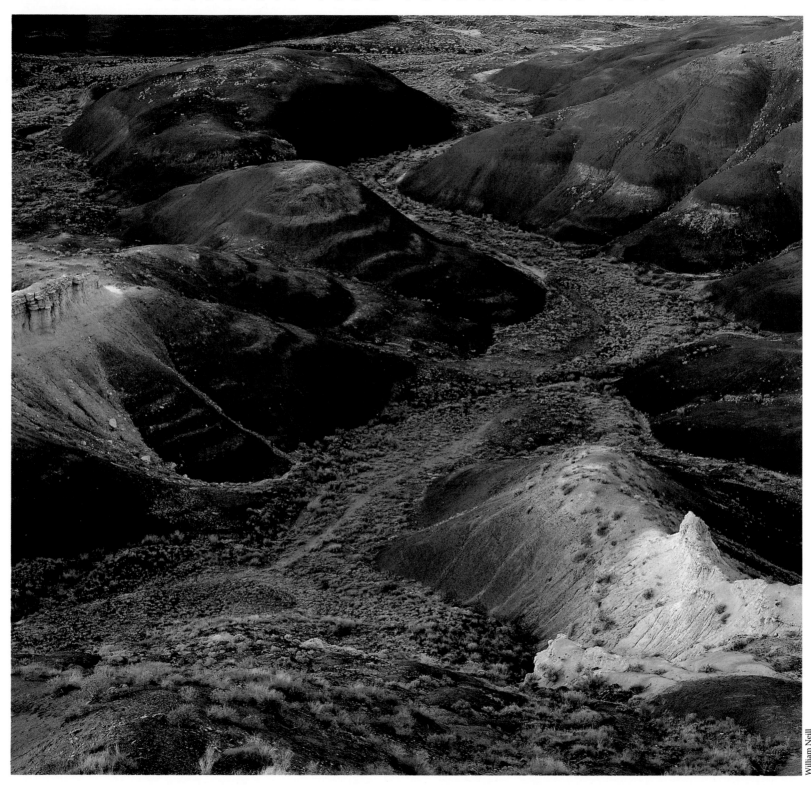

William Neill

importance to these people. Quantities of baskets are still needed for gifts at Hopi weddings and for ceremonial purposes.

Each of the three Hopi mesas has its own artistic specialty. First Mesa produces pottery, Second Mesa provides close-coiled basketry, and Third Mesa furnishes wicker basketry. Second Mesa baskets are made of finely split yucca (*Yucca angustissima*) sewn around a grass bundle foundation (*Hilaria jamesii*). Plaques, shallow bowls, and deep bowls are the common forms, but other shapes also appear. The work direction is to the left. Baskets made during the second half of the nineteenth century were constructed of very thick coils, often one inch in diameter, and tended to have simple, all-over designs. Aniline dyes were introduced during the 1880s with less than favorable results. However, a revival in the early years of this century has contributed to a successful return to native dyes.

Modern Second Mesa baskets have much smaller coils and the designs are more complex. The use of color—commonly black, red, yellow, and green on a white background—is also more complex in later work. The black and red are from native dyes; others are natural colors obtained from yucca. Common motifs are kachina masks, full kachinas, deer, eagles, corn, butterflies, clouds, highly conventionalized life forms, and geometric arrangements.

Third Mesa weavers excel in the wicker technique, the simplest variation of twining. In wicker, only one weft is used at a time, instead of two as in plain twining. Sumac or wild currant is used for the framework (warp) and peeled stems of rabbit brush are used for the weft. This is the most brilliantly colored of all Southwestern basketry. Although commercial dyes were used extensively around the turn of the century, native vegetal and mineral dyes have been favored since then. Mineral dyes are rubbed or painted on. When vegetal dyes are used, the prepared stems are first boiled in the dye, and the color is set by exposing the still-wet stems to the smoke of raw, burning wool.

Plaques and bowls are the dominant forms. A noticeable hump, caused by the crossing of the warp bundles, appears in the center of the bottom of these

Maggie Painter worked this realistic bird motif on a bead loom until it met with her satisfaction. She then referred to the loom-beaded strip while working on the basket. The use of a pattern is unusual and normally associated only with innovative designs. Traditional Chemehuevi designs are well known and patterns are generally not needed. This basket, eight inches in height, was completed in 1961, late in Painter's life.

baskets. Designs occur in great variety, including static bands, whirls, life forms, and kachinas.

Several other utilitarian baskets are made on all three mesas, such as the plaited "ring basket," or sifter, and plaited and wicker piki trays. But the wicker peach basket (carrying basket), which was made and used by Hopi men, has not survived.

For hundreds of years the Havasupai have remained in relative isolation, living and farming the floor of their deep and narrow red-walled canyon. Even today, their mail and most of their visitors come in over a rather arduous eight-mile horse and foot trail. Not until the 1870s did prospectors begin to plague the Havasupai. The government set up the Havasupai Reservation in 1880 to protect the two hundred members of the tribe from the outside world.

Prior to the late nineteenth century, Havasupai basketry was primarily of the twined technique and closely resembled the prehistoric Great Basin types. These baskets were mostly utilitarian and little was added in the way of decoration. In the late 1800s, however, close-coiled baskets were produced. These baskets bore patterns in black that are suggestive of Yavapai origin. The Hopi, in particular, developed a fondness for these baskets and a brisk trade developed between the tribes. Commercial outlets such as the Fred Harvey Company's Hopi House and other Indian shops in the Grand Canyon also promoted these "fancy baskets." As the demand for nonutilitarian, coiled basketry increased, less attention was paid to the traditional twining.

Materials and techniques used in Havasupai coiled-ware closely resemble those of the Western Apache and Yavapai. For this reason Havasupai basketry is often misidentified. A number of traits, however, taken in combination, can be relied on for accurate identification. For example, many older Havasupai coiled baskets had braided rims and bright aniline colors. The black rim and black start, which are almost universal on Apache and Yavapai baskets, are often absent on Havasupai ware. Thus, Havasupai baskets frequently have the appearance of being unfinished Yavapai or Apache baskets.

The peak in Havasupai basketry occurred in the

Mary Snyder (1852 to 1951) was one of the best known of the Chemehuevi weavers. Among the weavers of her tribe, she is credited with originating both the bug and rattlesnake designs. Other Chemehuevi weavers were not free to use these designs without her permission. This basket, with the bug design, is twelve inches in diameter.

1930s. Better preparation of materials, a broadened range of forms, and an expanded awareness of design characterized this period. Technically, the work of this period rivals the best done anywhere in the Southwest.

At present, a number of Havasupai women are producing baskets of various types. Most are small baskets and somewhat hastily made for sale to the ever-increasing number of visiting tourists, however, a few weavers are doing exceptional work.

The Chemehuevi, an offshoot of the Southern Paiute, were adopted into the Southwest by the Mohave. Prior to the mid-nineteenth century, they roamed over the eastern half of the Mohave Desert in California subsisting by hunting and gathering, but at the allowance of the Mohave, they drifted over to the Colorado River. In this new environment, they began floodwater farming in the Chemehuevi Valley and Colorado Valley. Chemehuevi religious concepts, warfare, and mode of subsistence were heavily influenced by the Mohave.

The Chemehuevi were eventually given their own reservation in Chemehuevi Valley, but they now reside primarily on the Colorado River Indian Reservation near Parker, Arizona.

Chemehuevi coiled basketry is noted for simplicity of design and perfection of technique. The three-rod triangular foundation is used, but the work direction is to the right. The latter trait is unique in the Southwest—weavers of all other tribes, except for left-handed members, coil to the left. Willow, and occasionally cottonwood, is used as the principal sewing material, and designs are executed in devil's claw, juncus, or, rarely, split flicker quills.

Chemehuevi baskets made before 1900 have extremely simple geometric designs in black with large undecorated areas. Much of their beauty lies in the almost perfect control of contour and fine, even stitching. Rather small jars with gracefully rounded shoulders and shallow bowls are the most common forms. Some aniline dyes were used in the late 1800s but this soon went out of fashion.

In later, innovative work, some original designs were the property of individual weavers and could not be used by another weaver without specific per-

mission. (For example Mary Snyder was associated with her realistic bug and rattlesnake representations. Maggie Painter was known primarily for her variations of the butterfly motif, and Kate Fisher was known for her birds.) Adherence to this custom was such that if shown an anonymous basket, an experienced weaver could consistently make a positive identification based on the arrangement and choice of design. Other designs were considered tribal and anyone had the right to use them. Anthropomorphic motifs were seldom used.

Very few baskets have been made in recent years, although there have been some attempts to create a revival.

A number of other tribes in the Southwest also make, or have made, a variety of baskets. North of Tuba City, Arizona, a small group of San Juan Paiutes produces traditional utilitarian wares, such as seedbeaters, burden baskets, parching trays, and winnowing trays, woven in variations of the twining technique. These weavers also produce open- and close-coiled baskets on a number of rod configurations. The preferred material is sumac (*Rhus trilobata*) although willow is used occasionally. Coiled basket types include traditional pitch-covered water bottles, Navajo "Wedding Baskets," and a modern style of tray with innovative or trader-influenced design concepts. Bright aniline dyes are often used for the trays to execute the cross-cultural design innovations.

The Navajo formerly made close-coiled basketry for both utilitarian and ritual use, but the craft declined to such an extent that even baskets required for religious purposes were mostly supplied by the San Juan Paiutes and the Utes. Traditional Navajo baskets were of sumac on a two-rod and bundle foundation. Designs were conservative and usually executed in native-dyed black and red. In very recent years, a revival of sorts has occurred. In addition to making the traditional wedding baskets, some younger weavers are creating much more innovative styles in exaggerated sizes for the non-Indian market.

Two Apache groups in New Mexico also produce a limited amount of basketry. The northern tribe,

33

the Jicarilla, weave rather coarsely coiled deep bowls and straight-sided baskets with lids. Recent work is decorated with simple to fairly complex geometric designs, life forms, and floral motifs—all in often harsh aniline colors. The principal sewing material is sumac. The foundation is either three or five rods bunched. The Mescalero, who live in southern New Mexico, make large shallow bowls with massive geometric designs in soft natural colors. Three types of foundation are used: two rods and a bundle, three rods and a bundle, or a wood slat and a bundle. All are arranged in a vertical position that results in a wide inflexible coil. The sewing material is yucca which, by different degrees of bleaching, gives green, yellow, and white; red-brown is obtained from the root of narrowleaf yucca.

The Rio Grande Pueblos have lost most of their basketry tradition. Plaited "ring baskets" are made at Jemez, and some coarse wicker work is occasionally done at Santo Domingo and a few of the other pueblos. The Puebloans still have a great fondness for fine examples of coiled basketry, and much of it can be found in their homes; practically all of it, however, has been acquired by trading with other tribes who continue to produce basketry.

The fact that native forms of basketry have survived to the present, even in limited quantity, reveals the tenacity with which the Southwest Indians have held on to their native cultures. Once-plentiful weaving materials have fallen victim to progress and have been sacrificed in the names of "phreatophyte eradication," "channelization," "watershed management," and other programs said to be in the public interest. Reservation water tables have fallen; rivers and streams have disappeared.

Economics alone cannot explain the continued existence of basketry—economically, basketry has not been viable for generations. Even at the crest of the present wave of popularity enjoyed by all things Indian, few full-time basket weavers can earn more than a few thousand dollars a year, whereas other highly acclaimed artisans achieve incomes approaching those of corporate executives. Individual basket weavers have not received the attention that Indian artists have in the other major arts and crafts

One of the most popular traditional Pima basketry designs is the squash blossom. The number of segments, or petals, can vary from three to as many as twelve. Grace Kisto of the Gila River Indian community devoted nearly a year of work to weave this shallow bowl. The basket is twenty-eight inches in diameter and was completed in 1973. Opposite: Both the Papago and Hopi use split yucca leaves for the sewing material in their coiled basketry. Shown here is yucca in one of the preliminary stages of preparation at Papago camp, Avra Valley, Arizona.

categories perhaps because the best basket weavers are, quite often, strongholds of Indian conservatism. In many traditional Indian cultures of the Southwest, excellence is perfectly acceptable, even expected, but to boast or become vain about one's own accomplishments is considered improper. A second, more practical reason is that a basket weaver's production is limited to only a few major works per year. Especially large or fine examples can require a full year or more to complete. As a result, the quantity of work is insufficient to allow a significantly wide distribution or to attract even a regional following.

The erosion of traditional Indian culture appears to be accelerating. Each succeeding generation is a bit less conservative than the last. Basketry has been the native American art form most resistant to change, but even this bastion is now giving way. As acculturation progresses, less pressure exists from within to conform to long-established tribal standards. Increased experimentation and innovation, though not always encouraged, are at least tolerated. And public recognition for personal achievement is more acceptable than in past generations. Clearly change itself is not always detrimental; it is often a matter of survival.

A few generations ago fine basketry was inspired by the very cultural fiber of the weaver. She wove baskets worthy to be taken into the afterworld by a loved one; she wove baskets to honor a tribal hero; she wove baskets to enhance her desirability as a potential wife; she never questioned the effort or time she spent because time was not viewed as money. But whether creations of the future can equal or surpass those of the past, whether incentives of contemporary mainstream America—desires for material success and personal recognition—can inspire the continued production of quality basketry remain to be seen.

34

36

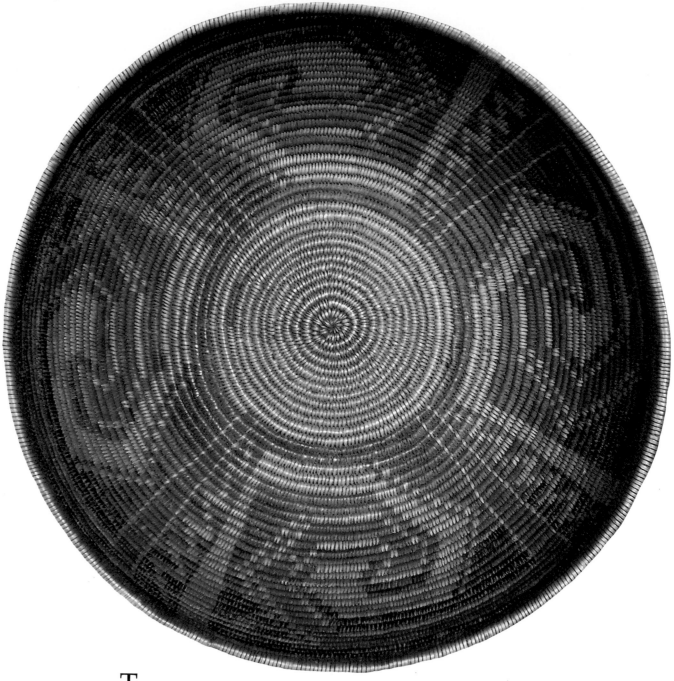

This superb Basketmaker III bowl was one of a cache of several baskets uncovered, oddly enough, by cattle seeking shelter in a shallow cave on a ranch in southern Utah. The extreme aridity of the Four Corners region accounts for the basket's remarkable condition. (9½ inches across; 4 inches deep)

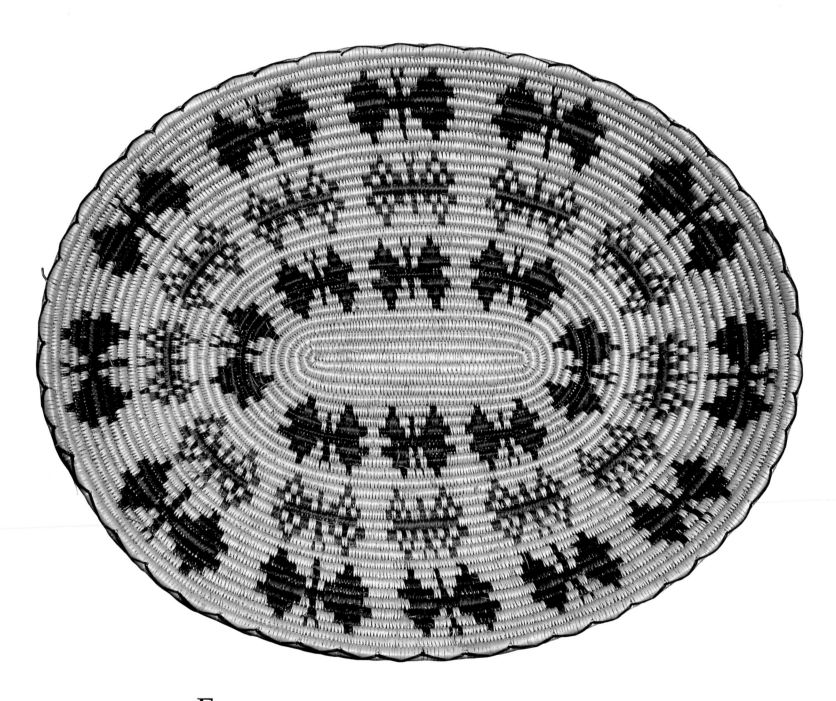

Ｆrom ancient to contemporary, basketry has generally held to tradition. Innovation, however, is gaining acceptance. Grace Lehi, a San Juan Paiute weaver, created this "new wave" basket using atypical designs. She and a small but active group of weavers are producing new designs, largely due to the influence of a prominent local trader.

38

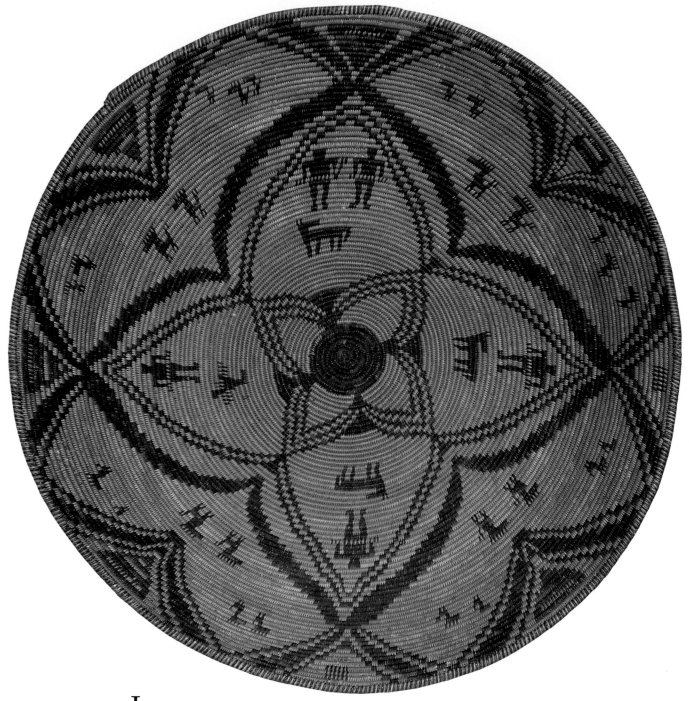

Large size (approximately twenty-five inches in diameter) and use of naturalistic motifs suggest that this Western Apache shallow bowl was woven for sale to the outside market. Figurative designs are merely decorative and have no particular symbolic significance.

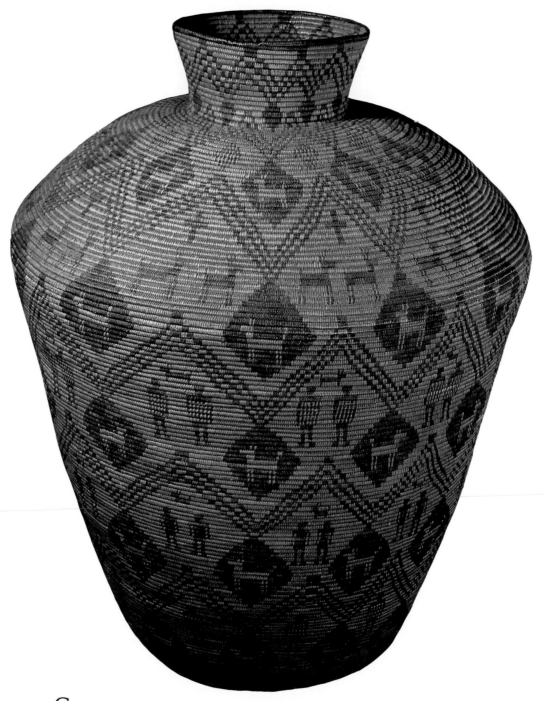

*S*torage ollas *of extremely large size were more common among the Western Apache than with
other Southwestern tribes. Nearly three feet in height, this masterpiece would have required well
over a year of full-time work to complete. (Circa 1900)*

40

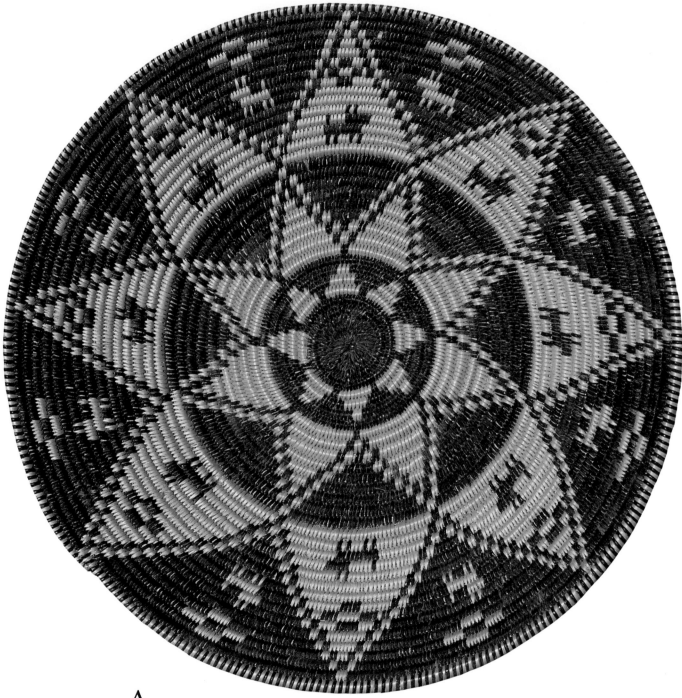

Ask any knowledgeable Yavapai who their finest basket weaver was and the reply will likely
be "Minnie Stacey." Minnie's technical mastery was unchallenged. This small finely woven bowl is
typical of her work during the 1930s and 1940s and exemplifies the best in Yavapai basketry art. Filler
elements represent dog and coyote tracks. (9 inches across; 2 inches deep)

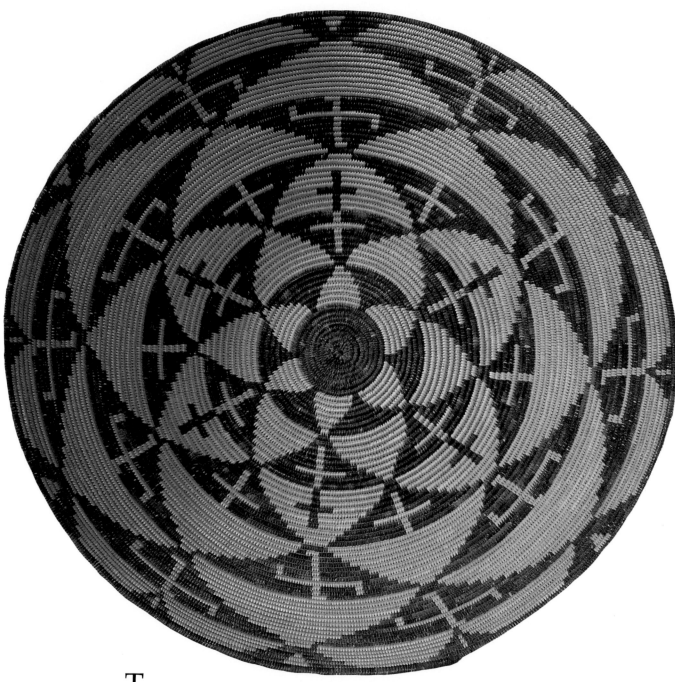

The complex geometric arrangement of this Yavapai shallow bowl is said to represent thunder-clouds. The swastika motif has long been used by the Yavapai, and most baskets bearing this design considerably predate World War II and share no association with the Nazi symbol. (17 inches across; 4½ inches deep)

42

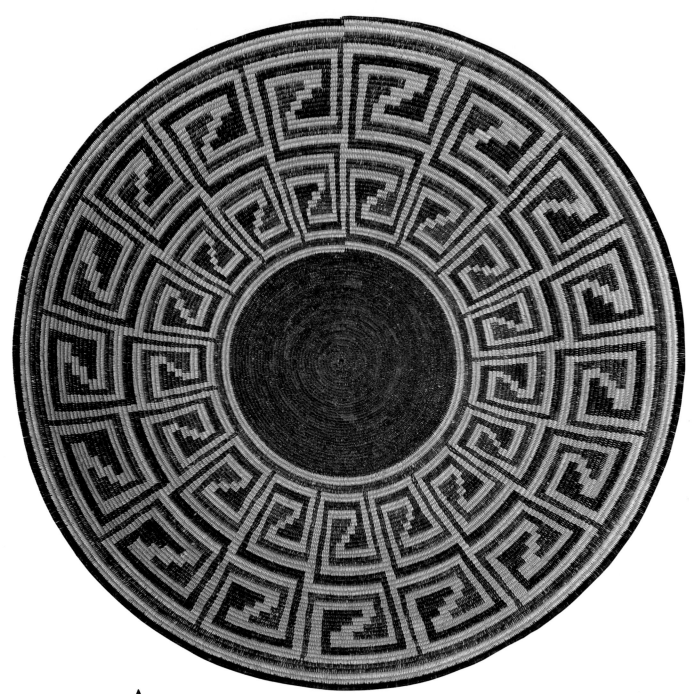

A dapted from designs on prehistoric basketry fragments, these contemporary Pima baskets by
Grace Kisto offer the best of the ancient and modern. The concept of equal and opposing elements in black
and red on a neutral ground derives from prehistoric times but did not survive into the historic period.
(22½ inches across; opposite: 28 inches across)

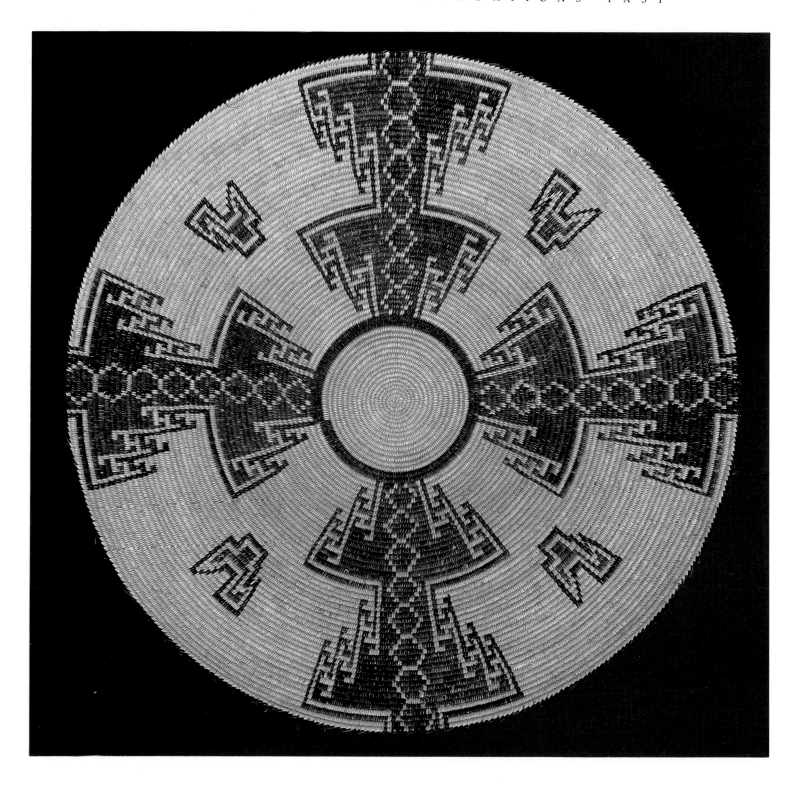

44

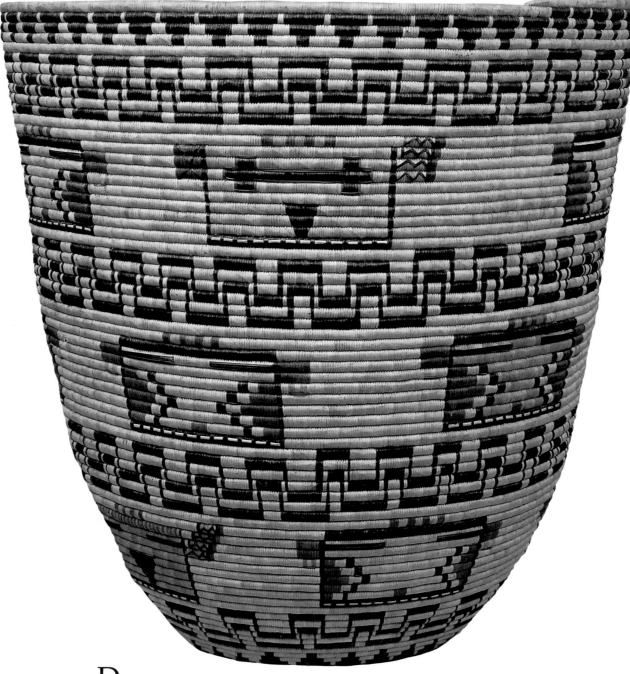

Deep baskets such as this one represent the influence of commercialization on Hopi Second Mesa wares. The amount of effort expended to make this basket is staggering. All colors are natural or native-dyed yucca. The polychrome figures are indicative of various kachina masks. (20½ inches tall)

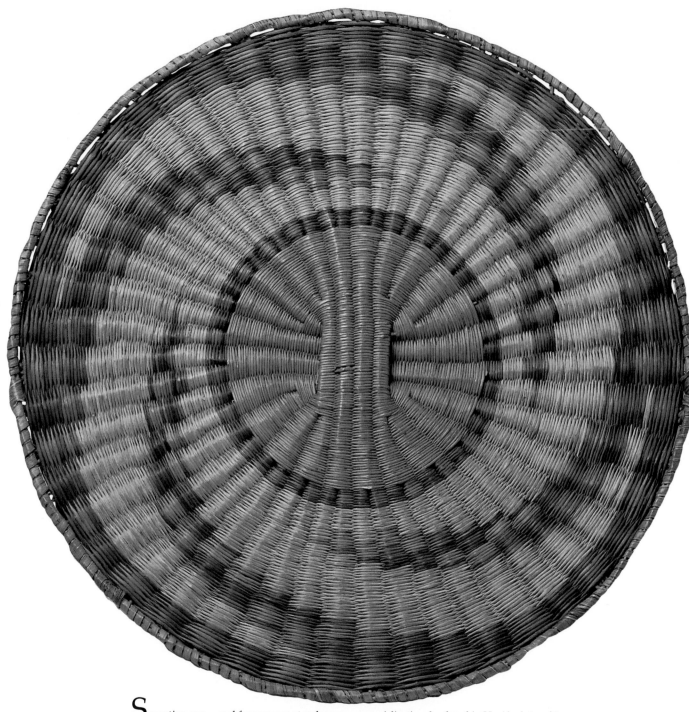

Some time ago—and for reasons yet unknown—a specialization developed in Hopi basket making. Wicker basketry, such as the example here, is made only in the villages of Third Mesa and in Moencopi. Traditional plaques of this type are still made for native use. The Hopi name is yungyapu for "flat wicker plaque." (16½ inches across)

46

The Pima refer to this design as the "whirlwind." Although the form is elegant, it did not originate with the Pima but instead with the tribes of central California. Technically one of the more difficult to achieve, the design is mastered here, with flawless execution, by an anonymous weaver. (Circa 1930)

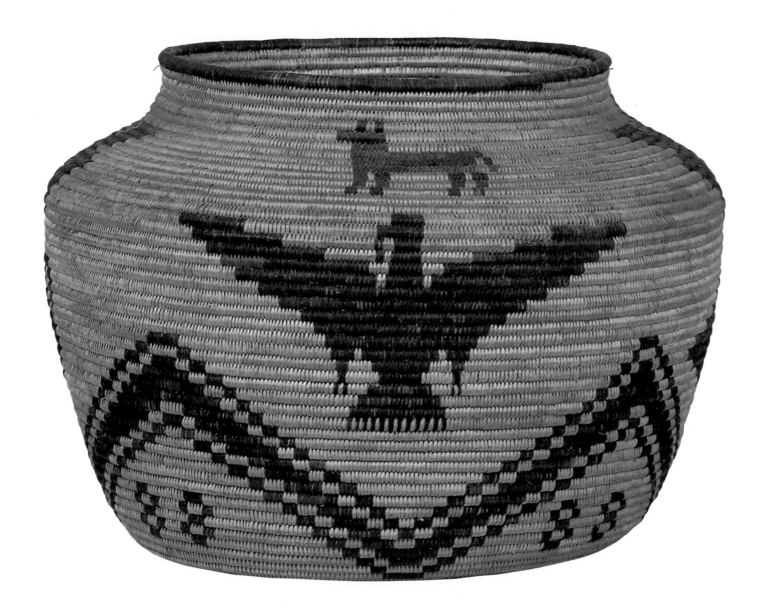

The fluorescence of Havasupai basketry occurred relatively late, in the 1930s. Documentation for this basket states that it was ". . . made by Lina Chikapanyja. Representing the highest art in basketry made by the best weaver of the Supai tribe . . . Guaranteed as above by Tuba Trad. Post Co., Tuba City Ariz." The eagle motif is fairly common for Havasupai baskets. (6 inches tall)

THE WOVEN SPIRIT

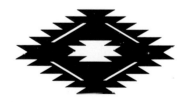

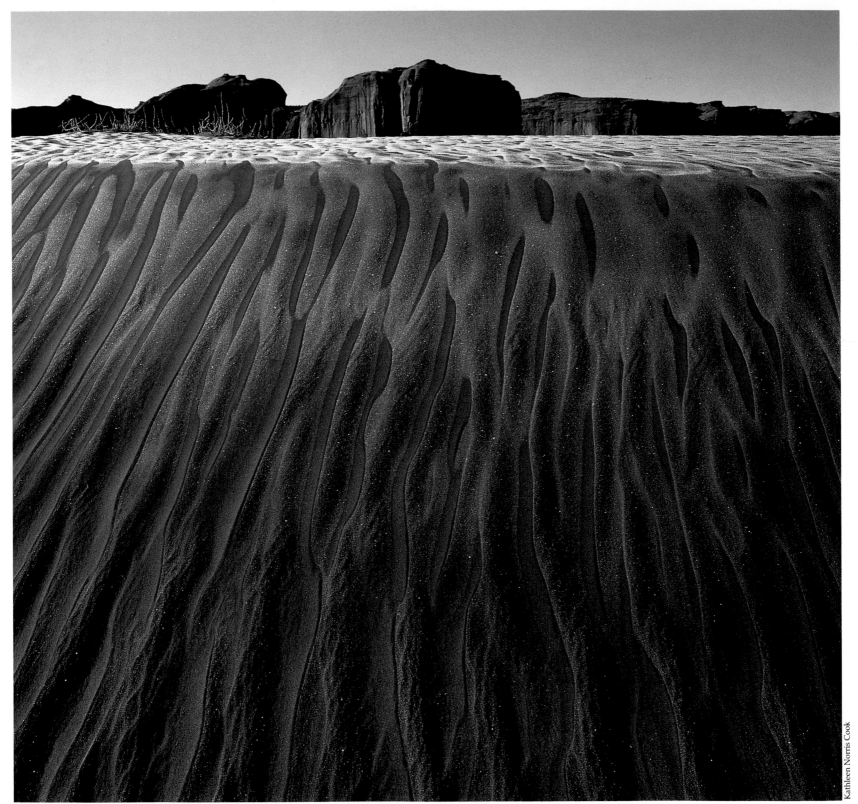

50

Monument Valley, Arizona; (*facing page*) Navajo manta fragment, circa 1850

Kathleen Norris Cook

THE WOVEN SPIRIT

BY SARAH NESTOR

T he bold, simple abstract stripes and diamonds of chief blankets, the syncopated rhythms and daring colors of "eye dazzlers," the intricate geometry of subtle earth-toned Two Grey Hills rugs only begin to demonstrate the range of Navajo textiles past and present. Prized by collectors the world over, Navajo weaving is synonymous with Southwestern Indian weaving for most people. Yet the Navajo are relative newcomers both to the American Southwest and to weaving. Their rapid technical mastery of the art and their numerous and continuous design innovations are a testimony to the dynamism of this remarkable people.

The Dineh—The People, as the Navajo call themselves, were part of an influx of Athabaskan-speaking hunters and gatherers who wandered south from Canada to the wide desert and open skies of northern New Mexico sometime between A.D. 1300 and 1500. Though they were a nomadic people, they also adopted the agriculture practiced by the Pueblo Indians already settled in the area. And, probably in the mid-seventeenth century, the Pueblos taught them to weave.

The Pueblo people had been weaving with cotton on upright looms since about A.D. 800. When Spanish settlers entered the area in 1598 they brought the rugged *churro* sheep, whose wool was quickly adopted for weaving. The Pueblo Indians were subjugated by the Spanish, forced to adopt their religion, pay

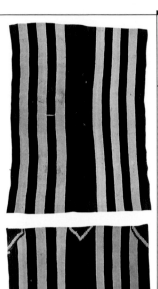

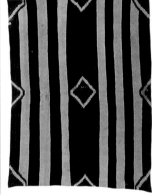

tribute, and labor in their fields. The mobile, elusive Navajos managed to avoid such subjugation, and frequently raided both the Spanish and the Pueblos for horses, sheep, and human captives. Some Pueblos chose voluntary exile with the Navajo to Spanish servitude; eventually, in 1680, the Pueblos revolted and drove the Spanish from the land. Many, fearing the oppressors' return, went to live with the Navajo, further enhancing the exchange of cultural and artistic traditions. By the time of the Spanish reconquest in 1696, the Navajos were weaving in wool both for their own use and for trade with the Pueblos. Soon they were trading with the Spanish as well, and were generally acknowledged as superior weavers.

Navajo legend says The People were taught to weave by Spider Woman, and surely this is an apt symbol for an ingrained sense of balanced patterning brought forth by patient, meticulous labor. In a more literal sense, Navajo women undoubtedly learned the art from the Pueblo men who stayed and sometimes intermarried with them during the latter part of the seventeenth century. Pueblo men were traditionally the weavers in their sedentary culture, but among the nomadic Navajo, as the men continually hunted and raided, the task of weaving fell more naturally to the women.

The tools and techniques adopted from the Pueblos by the Navajo in the seventeenth century are virtually unchanged to this day. The wide vertical or upright loom frame is made of logs set into the desert ground and lashed together. Smaller pieces of wood serve as beams, battens, heddles, shed rods, tension bars, and weaving forks. The loom is warped with a continuous length of yarn wrapped in figure eights, the tension kept even. This contributes to the strength of the finished piece. The weaver sits on the ground in front of the loom and weaves from the bottom up. Because the loom is so wide, Navajo women developed a technique of building up small sections of particular colors and patterns rather than weaving entire unbroken rows of horizontal weft. The technique, known as "tapestry weaving," results in the characteristic "lazy line," a perceptible line where two sections of weft meet but do not interlock. (This is not to be confused

A Phase II chief blanket (top), circa 1850–1865, shows the characteristic breaking of bands with red rectangles. Here, the rectangles are in small pairs rather than as one larger red block, which is perhaps more typical. Bottom: *A later chief blanket, Third Phase, circa 1870–1880, shows the nine-spot chief pattern of stepped diamonds against alternating stripes. Although, relatively subdued here, diamonds were at times woven in sizes so large that they dominated the design, nearly obscuring background stripes.*

with the "spirit trail," a weft line of contrasting color running to a corner and off the edge of many Navajo textiles which enables the spirit of the weaver to escape her work.) Probably because small widths are woven and battened down at one time, Navajo weaving is noted for its density—wefts are packed together so tightly (from twenty to one hundred wefts per inch) that warp yarn is not visible.

The materials for weaving were also borrowed by the Navajo from the Pueblo Indians, though these changed radically in the nineteenth century through interaction with Anglo Americans. Churro wool, with its long, straight fiber, was easily cleaned, carded, and spun, and its low oil content allowed a ready absorption of dyes. By simply shaking or beating the wool against desert rocks and picking out any twigs, or washing it in yucca-root suds, the wool was cleaned. Carding with thistle-toothed cards introduced by the Spanish completed the cleaning process. (Modern-day cards are metal toothed but otherwise similar.) Fibers were spun with a hand spindle or *malacate* consisting of a spinning stick and whorl anchored to the ground. Yarn was single ply and Z-spun—twisted in a counter-clockwise direction from the bottom up. Warp yarn, which had to bear greater tension than weft, was respun at least three times. (Modern weft yarn is so tense that it springs and doubles back on itself before it is stretched out on a loom.) Colors in early Navajo blankets were taken from a natural palette of white, beige, brown, and black, to which were added yellow dyes from local plants such as chamisa, indigo from Mexico (the two sometimes combined to make green), and red (cochineal or lac) yarns raveled from cloth obtained from the Spanish.

Navajo blankets of the mid-seventeenth to mid-nineteenth century, now known as Classic Period blankets, were prized by Indians and Spanish alike for their high quality and dense weaving, which offered protection from cold, wind, and rain. Navajo men and women wore their blankets, which were woven wider than long, wrapped around their bodies in various ways, depending on the amount of warmth and freedom of movement needed by the wearer. The horizontal blankets, or "mantas," were

52

folded in half and sewn up the side and on the shoulders to form dresses for the women. Blankets were also used for sitting on the desert floor and, with sheepskins, for sleeping at night. They were hung in hogan dwelling doors to keep out winds, animals, and, possibly, wandering spirits. Blankets, then, can be said to have played a far more fundamental role in Navajo society than do our blankets today—the woven textiles were constant companions to their owners, closely identified with them.

The design of early Navajo blankets, based upon horizontal stripes with a broader band in the middle, at waist level, must have dignified the appearance of the wearer, representing him as an individual and the tribe as a whole while it also mirrored the lines of the broad sky, mesas, and the desert floor over which he walked. Lt. James H. Simpson, leader of the first American expedition into the Navajo world in 1849, was struck by the resemblance of a group of motionless Navajo in their blankets to "stratified rock formations."

Best known of the Classic Period striped blankets are those referred to today as chief blankets. They certainly denoted status, though their use was not restricted to chiefs. The evolution of chief blanket designs from simple to complex is generally traced through four overlapping phases. Phase I chief blankets (1800–1850) are composed of alternating black and white stripes, with wider bands at the ends and in the middle. Indigo stripes are sometimes found within the broader bands, occasionally associated with stripes of raveled red. Phase II blankets (1800–1870), departing from simple stripes, have the addition of twelve spots of red woven into the indigo stripes. Phase III blankets (1860–1880) incorporate quarter, half, and full terraced diamonds into the broad bands. And in Phase IV chief blankets (1870–1885), diamonds sometimes grow so large that stripes recede into the background. It is likely that the terraced designs of these blankets were inspired by the designs on Navajo coiled basketry.

In addition to mantas, Navajos of the Classic Period wove Spanish-influenced serapes, longer-than-wide blankets that hung long when worn as shoulder blankets. These, like the horizontal man-

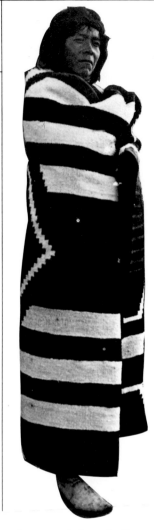

The contemplative and self-contained bearing of this Taos chief, circa 1911–1913, is enhanced by the blanket in which he has wrapped himself. The large terraced diamond at the center of the blanket characterizes it as a Classic Period Phase III chief blanket.

tas, were characterized by the fine, dense weaving for which Navajo weavers were famous. Their designs also evolved from simple stripes to increasingly complex patterns of terraced steps and diamonds. Saltillo serapes, introduced from Mexico to New Mexico by the Spanish in the early nineteenth century, particularly influenced Navajo weaving design. Characterized by dominant central diamonds, vertically columned backgrounds of sharply serrated patterns, and borders, Saltillo serapes were transformed by the always adaptable but independent Navajo weavers rather than simply copied by them. Central motifs were relatively large, simple, and bold, as were the serrate motifs and border patterns in late Classic Period Navajo serapes.

Throughout the eighteenth century the Navajos continued their traditional trading with and raiding against surrounding Indian groups and Spaniards. The latter activity culminated in the 1805 Massacre Cave incident, in which numerous Navajo women, children, and old men were exterminated by a party of vengeful Spanish soldiers. A number of the oldest extant weavings, deteriorating but untouched, were found a century later in the cave in a wall of the Canyon del Muerto.

When Mexico, including modern-day New Mexico and Arizona, won independence from Spain in 1821, trade was opened to the United States; Navajo blankets were among the many items that moved along the Santa Fe Trail. Chaotic conditions encouraged the Navajo to escalate their raids once again, however. The Southwest became part of the United States in 1848, and after a series of treaties with the Navajo were made and broken, the U.S. Army took action in 1863. Under the leadership of Col. Kit Carson, a successful guerilla war was waged against the Navajo, whose crops, sheep, and houses were systematically destroyed. Eight thousand Navajo men, women, and children made the "Long Walk" to internment at Bosque Redondo near Fort Sumner in eastern New Mexico.

All aspects of Navajo culture, including their weaving, were profoundly affected during their traumatic years of exile. When they were allowed to

53

54

An interior shot of Hubbell's Trading Post at Ganado, Arizona, shows dozens of the watercolor
paintings Juan Lorenzo Hubbell hung on the walls as models of his favorite rug designs for Navajo
weavers in the area. A pictorial rug depicting the American flag can be seen in the lower left corner.
Opposite: A Navajo weaver at her loom. The weaving is suspended in a rectangular frame of four
beams, the top and left ones out of sight in this photograph. The shed rod at the top separates alternate
pieces of warp yarn, and below it are the heddle and batten. As is typical of Navajo tapestry weaving,
a section which only extends part way across the rug is being built up by the weaver.

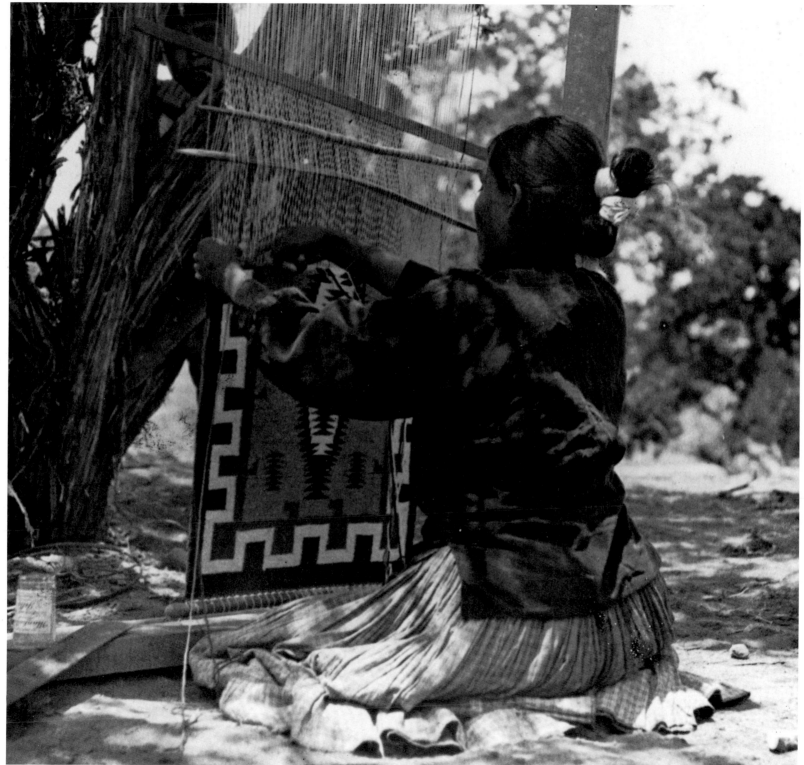

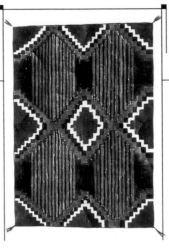

This is a reproduction of one of the watercolor paintings Juan Lorenzo Hubbell used to teach old designs to new weavers and also to allow customers to commission a rug of a particular pattern. The Phase III chief blanket design is typical, although the color scheme is less traditional.

return to their diminished reservation in New Mexico and Arizona five years later, with the understanding that they would raid no longer, the impoverished Navajo struggled to regain their independent life style. They were issued sheep and commercial weaving materials, and traded wool and blankets for the staples they needed at the trading posts that sprang up on their reservation in the late nineteenth century.

The period of rapid transformation spanning the mid-1860s to mid-1890s is often called the Transition Period of Navajo weaving. The Navajo had been issued thousands of Saltillo serapes at Bosque Redondo, reinforcing these design patterns in their own weaving. Charles Amsden has speculated that the increasing use of Saltillo-inspired borders in Navajo weavings during this period reflected the new boundaries imposed on the lives of the Navajo. Probably the most fundamental change in Navajo weaving was wrought by the issuing of large quantities of commercial Germantown yarns and cotton string to the weavers during their internment and after their return to their homeland. The immensely varied and brilliantly colored aniline-dyed yarns led to creative experimentation once again.

The most dramatic results were the explosive and many-colored, pulsating "eye dazzlers," which were disliked for their lack of subtlety by early twentieth-century traders and buyers but have found a more receptive market in the past two decades. Untraditional and discordant colors such as synthetic purple, red, turquoise, green, and yellow might be used in a single blanket, its serrated, zigzagging Saltillo-type patterns often outlined with thin lines of contrasting colors, so that the eye is literally dazzled. It has been postulated that these blankets reflected the cultural disorientation Navajo weavers experienced at the time; whether or not this is true, they certainly reflected the new materials and patterns made available to them.

One creative response to the alien Anglo-American culture into which the Navajo were thrust was the pictorial blanket produced during the Transition Period. Foreign objects such as cows and other animals, labels from food issued to them, trains and other vehicles, American flags and eagles, and letters of the alphabet all became design motifs, the objects (including letters) usually reversed for symmetry's sake.

Another type of blanket developed from the fact that, from early times, Spanish settlers had raided the Navajo for captives who were used as household servants. This practice led to the development during the nineteenth century of "slave blankets" woven by Navajo servants, which were characterized by the combination of traditional Navajo techniques and designs with the pastel colors and some design elements favored by Spanish weavers.

Technical experiments in weaving were also made during the Transition Period. Twill-woven saddle blankets (most commonly over-two, under-two, moved over by one warp thread in each weft row to create diagonal lines), two-faced weave (in which a tapestry design appears on the front and a striped pattern on the back of a single textile—the latter woven out of the weaver's sight!), and double cloth (two pieces of cloth joined at intervals) were all undertaken with masterful results.

By the end of the nineteenth century, Navajo weaving was a commercial enterprise. Textiles were made almost entirely for the Anglo-American market rather than for the Spanish, other Indian groups, or even the Navajos themselves. Following the internment at Bosque Redondo, Navajo women had come to adopt a version of Anglo-American women's blouses and full skirts in place of their traditional mantas, and the clothing of Navajo men also more closely resembled that of the dominant culture. And among the Pueblo Indians, weaving, chiefly for ceremonial purposes, came to be limited to the Zuni, who wove almost entirely for themselves, and the Hopi, who wove—and continue to weave—for themselves and other Pueblo Indian groups.

The all-important middlemen between the Navajo and their clients were the hardy souls who operated isolated trading posts in the Navajo country beginning in the 1870s. Early traders like Thomas Keam in the Hopi country and Juan Lorenzo Hubbell in the Ganado area in Arizona were respected by Navajos and visiting Anglo Americans

56

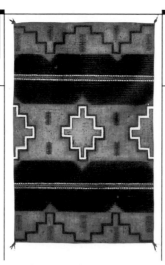

In this watercolor painting, which also hung in Hubbell's Trading Post as a model for local weavers, traditional design elements are featured that the trader encouraged. Hubbell died in 1930, but the post remains open today.

alike. After his death in 1930, Hubbell's operation continued under the direction of his son Roman; the famous red-rock trading post, now operated by the National Park Service as a historic monument, remains active and can be visited to this day.

The prosperity of the Navajo grew rapidly during the 1880s, but was seriously threatened in the early 1890s when their rangelands, already overgrazed, suffered a severe drought and many of their sheep died. This unfortunately coincided with a nation-wide drop in the price of wool. The weaving of blankets, meanwhile, had been carried on increasingly with the use of commercial Germantown wool for weft and cotton string for warp.

At this perilous juncture the traders became a catalyst that caused Navajo weaving to change radically once again, quite possibly saving it from extinction. In place of the blankets traditionally so integral to the Navajo way of life, weavers were encouraged to produce rugs of heavier yarns, which were more obviously useful to the Anglo-American market. In order to raise the quality of the rugs and sell them as genuinely handmade, traders paid weavers higher prices for textiles that were of a superior technical quality, woven from the wool of Navajo sheep, and naturally dyed. Designs and colors compatible with the tastes of the traders and their clients fetched a higher price, certain styles becoming associated with and named after the trading posts around which they were made. For example, Juan Hubbell encouraged the use of Classic and Transition period motifs, hanging watercolor design samples on the walls of his trading post as inspiration for weavers. And trader J. B. Moore at Crystal, New Mexico, promoted the use of design motifs derived from oriental rugs. Tourism to the Southwest was a booming industry in the early twentieth century, and traders also advertised their wares in catalogs that were sent back east.

The Modern Period of Navajo weaving, dominated by what were originally trader-influenced rug designs for the Anglo-American market, has extended from the turn of the century to the present day. The regional styles of rugs that developed in the early days continue to be made and sought after

by collectors. Thanks to the efforts of certain patrons in the earlier part of the century, notably Mary Cabot Wheelwright, the quality of yarns has also improved, and the use of natural vegetal dyes has experienced a strong revival. With access to modern transportation since World War II, Navajo weavers have become less dependent upon traders, weaving designs from any regions they choose and continuing to make innovations within these styles. An alphabetical listing of some of the best-known modern styles follows, but gives only a general indication of the wide range of Navajo textiles available to the contemporary collector.

Burntwater rugs incorporate oriental-rug inspired design motifs and feature natural colors with red. *Chinle* rugs utilize simple striped designs without borders as well as a variety of vegetal dye colors, sometimes in conjunction with black. *Coal Mine Mesa* rugs, woven in vegetal colors, represent a return to such technical weaving variations as double saddle blankets, with overall diamond or other geometric patterns and raised-outline patterns in which wefts regularly float over several warps. *Early Crystal* rugs, developed by J. B. Moore, use oriental-rug design elements such as a very large central motif of two or three sections and swastikas, latch hooks, and "airplanes," as well as non-oriental arrows. Early Crystals are woven in natural black, grey, and white with red. A *New Crystal* style rug, woven since World War II and dissimilar from the Early Crystals, features stripes with intentionally wavy lines in natural black, grey, white, and brown, and vegetal rust and gold. *Ganado* rugs, originally developed around Hubbell's Trading Post, feature simple Classic and Transition period stripes and terraced designs or large central designs with double borders, and are distinguished by their color scheme of natural black, grey, and white and dark "Ganado red." *Kinlichee* rugs are technically innovative, combining an overall pattern of two-faced weave and twill in several colors. *Nazlini* rugs are characterized by the use of synthetic and vegetal dyes, sometimes including pink, and borderless stripes which often contain stylized plant forms. *Red Mesa* rugs carry on the traditional jagged, outlined designs and bright

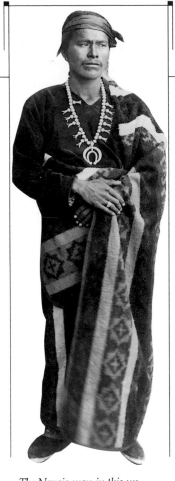

colors of "eye dazzlers." *"Storm Pattern"* rugs, associated with J. B. Moore, have a design composed of varied elements including central and corner rectangles connected by zigzagging lines (hence the name) and other interspersed shapes in various colors. *Teec Nos Pos* rugs incorporate "floating" motifs—designs derived from oriental rugs—in tan or white, finely outlined in black, that sit independently on a solid-colored grey or tan background. Small spots of red are sometimes interspersed through the rug, giving rise to the term "jewel pattern." *Two Grey Hills* rugs, perhaps the most highly prized Navajo rugs among collectors today, originated at Ed Davies' Two Grey Hills and George Bloomfield's Toadlena trading posts in New Mexico. Characterized by particularly high weft counts, elaborate designs that are derived from oriental rugs, and several patterned borders, Two Grey Hills rugs are the only modern Navajo rugs with a color scheme limited to grey, black, brown, beige, and white. They frequently incorporate a "spirit trail." *Wide Ruins* rugs, developed by traders William and Sallie Wagner Lippincott at Wide Ruins, Arizona, are composed of simple, borderless, striped designs. Their unusual vegetal colors are pastel and do not include black.

Despite the overwhelming array of blanket and rug colors and designs found in Navajo textiles of the last three centuries, some very general qualities seem to prevail, to stamp a textile as "Navajo," reflecting a certain Navajo spirit. Kate Kent has said in her book, *Navajo Weaving: Three Centuries of Change,* that harmonious color and balanced design are most frequently mentioned by Navajo critics themselves as the essential aesthetic qualities in a textile. Technical factors such as uniform tension, straight edges, densely packed weaving, and the precise carrying out of design ideas are also deemed aesthetically important by Navajo weavers. And one has only to attend one of the periodically held Navajo rug auctions at Crownpoint, New Mexico, to overhear comments of this kind as Navajos, along with Anglos, scrutinize rugs before an auction begins. The judgment that colors are harmonious is certainly subjective, and any use of "harmony" in reference to the colors of Navajo weaving must be broad enough to

The Navajo man in this undated photograph is wearing a blanket that includes the repeating element of a cross within a stepped diamond, which in turn is surrounded by a serrated eight-pointed figure. The draping of the blanket allows the wearer relative freedom of movement. Opposite: A view of Antelope House in Canyon del Muerto, Canyon de Chelly. The structure, and the rock art behind on the cliff face, are ancient—preserved and undisturbed today on Navajo lands.

include the startling juxtaposition of "eye dazzler" colors as well as the subtly contrasting natural tones of Two Grey Hills rugs. Certainly, earth tones with touches of brighter color, as well as large blocks of red and dark blue, seem most typical of Navajo textiles; while pastel colors appear, they do not predominate. Rugs of many cultures are characterized by symmetrical, balanced designs, and indeed, Navajo textiles are no exception, but there is a seemingly endless variety of Navajo weaving designs that are perfectly poised, held still in a moment of absolute balance.

Increasingly, through the course of the last three centuries, outside influences have played a part in Navajo weaving. Always adaptable and pragmatic rather than conservative and traditional, the Navajos have never simply copied the textiles of other cultures, but have taken ideas and transformed them. The value placed on freedom and the beauty of individual expression in Navajo culture encourages this sort of creativity. A respect for technical skill, patience, and "keeping busy," all requiring individual concentration and discipline, also permeates the Navajo way of life, which is certainly not a life of ease, and yet allows large blocks of relatively solitary time.

The future of Navajo weaving is uncertain, bound up as it is with the survival of traditional Navajo values and way of life. As younger people increasingly choose to enter the mainstream of American culture, the number of Navajo weavers continues to shrink, and most of those pursuing the craft today are older women. Working Navajo weavers presently cannot meet the demands of collectors, and the prices of their textiles continue to rise in consequence. It is to be hoped that the love of the weavers for their art, coupled with the appreciation of collectors for the intrinsic beauty of their works, will ensure the survival of Navajo weaving through yet another transitional period. Certainly, if Navajo weavers continue to work at their looms, Spider Woman will guide them to create harmonious and balanced yet continually fresh patterns—new windows that look both into and out from the world of the Navajo.

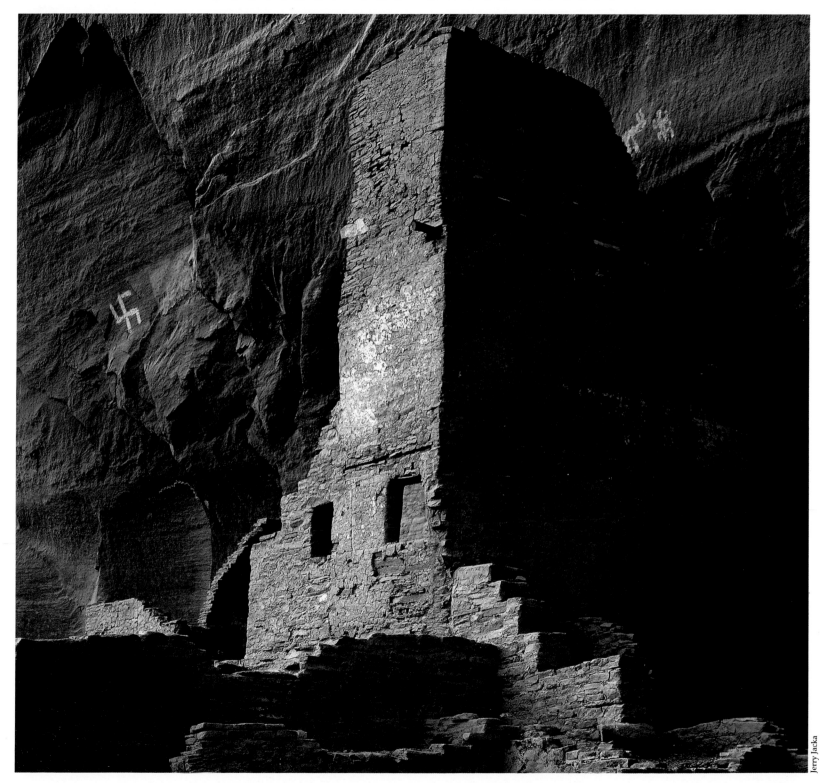

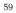

Jerry Jacka

The floor of Canyon de Chelly is farmed by the Navajo. They have given names to the canyon's ancient ruins and many of its natural features, including a spectacular isolated spire, which they call Spider Rock. According to Navajo legend, First Man and First Woman were taught how to weave by two of the Holy People—Spider Man told how to make a loom, and Spider Woman told how to weave on it. The loom's crosspoles were made of sky and earth cords, the warp sticks of the suns rays, the healds of rock crystal and sheet lightning, the batten of the sun's halo, and the comb of white shell. The four spindles were made of zigzag lightning with a cannel coal whorl, flash lightning with a turquoise whorl, sheet lightning with an abalone whorl, and a rain streamer with a white shell whorl.

When a Navajo girl is born, a spider web is sought that has been woven at the mouth of a hole. The web is rubbed on the baby's hands and arms so that she will be a fine and tireless weaver.

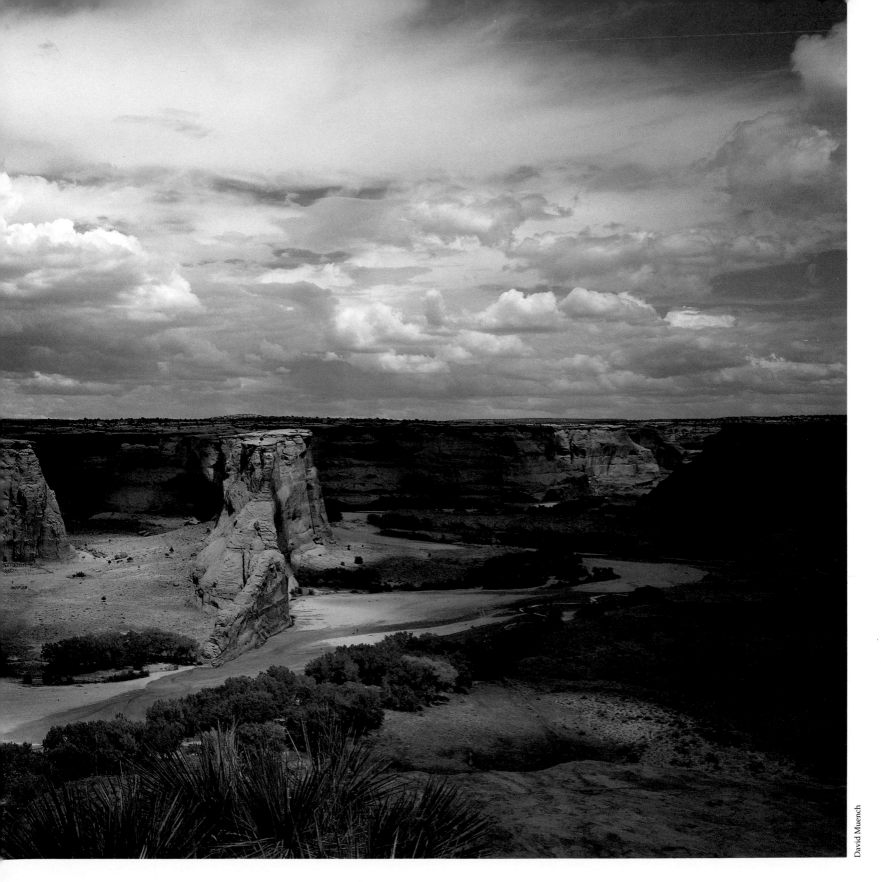

This bold Classic Period chief blanket, circa 1870–1880, demonstrates the growing dominance of
diamond motifs during this period, which relegate stripes to the background. The dark and light
natural stripes form four diamonds of their own, also strongly vying for attention. The full terraced
diamond at the center, quarter-diamonds at the corners, and half diamonds at the centers of the four
edges makes this a typical Phase III blanket; interest is added by the zigzag "lightning" lines.

62

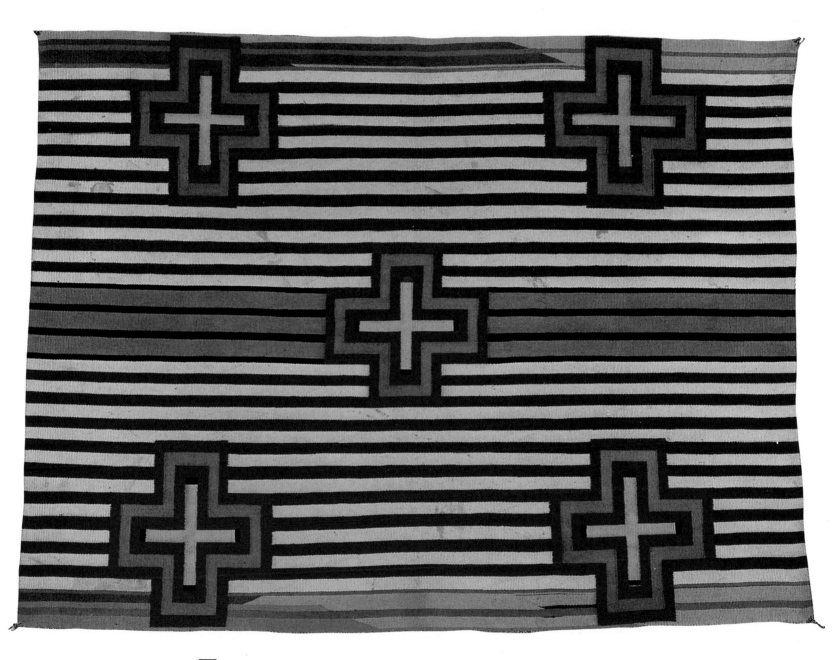

*T*he unusually subtle colors and relatively small-scale motifs of maroon and natural white stripes,
blue green and black center stripe, and five red, blue green, white, and black "Spider Woman crosses"
make this finely executed Phase III chief blanket (circa 1875) a piece of serene elegance. Lazy lines,
revealing the uneven building up of parts of the weaving, are particularly evident at the top and bottom.

64

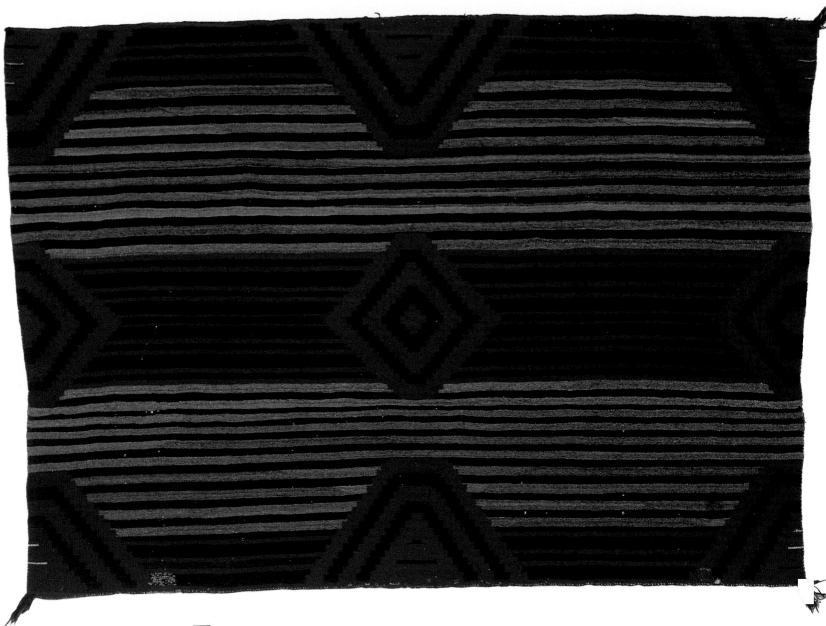

The subdued narrow grey and black stripes of this piece (circa 1870) are typical of women's shoulder blankets in the Classic Period, but only a few women's blankets, like this one, also feature the bright red nine-spot diamond pattern more typical of Phase III chief blankets. Two small natural-dyed yellow bars can be seen in each of the four quarter-diamonds, and blue tassels remain at three of the four corners.

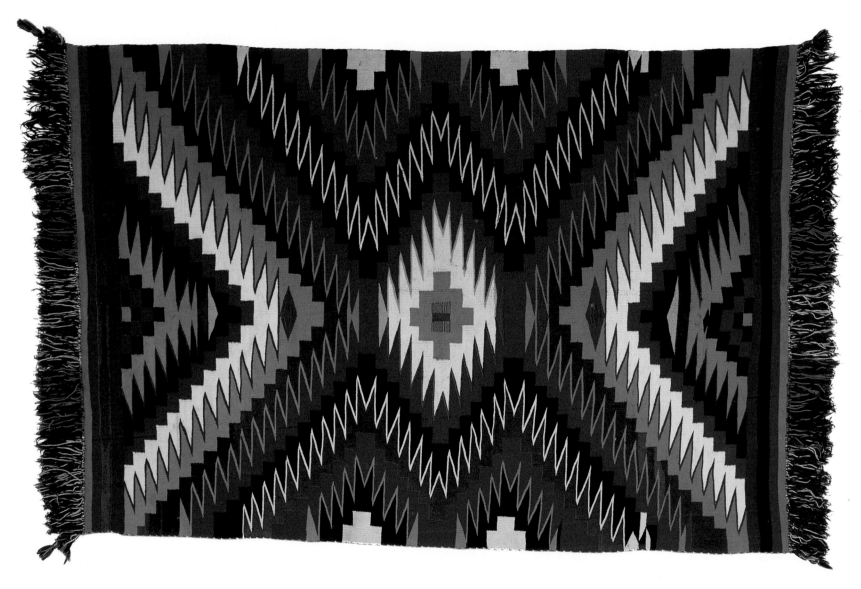

The vivid red, yellow, green, maroon, black, and white colors and humming activity of the sharply serrated and stepped zigzagging lines and lozenge motifs make this blanket, woven prior to 1915, a typical "eye dazzler" of the Transition Period of Navajo weaving. Such pieces, produced following the Navajos' internment at Bosque Redondo, utilize a newly available wide range of commercially dyed colors. This spectacular blanket carries an unusual multicolored fringe.

66

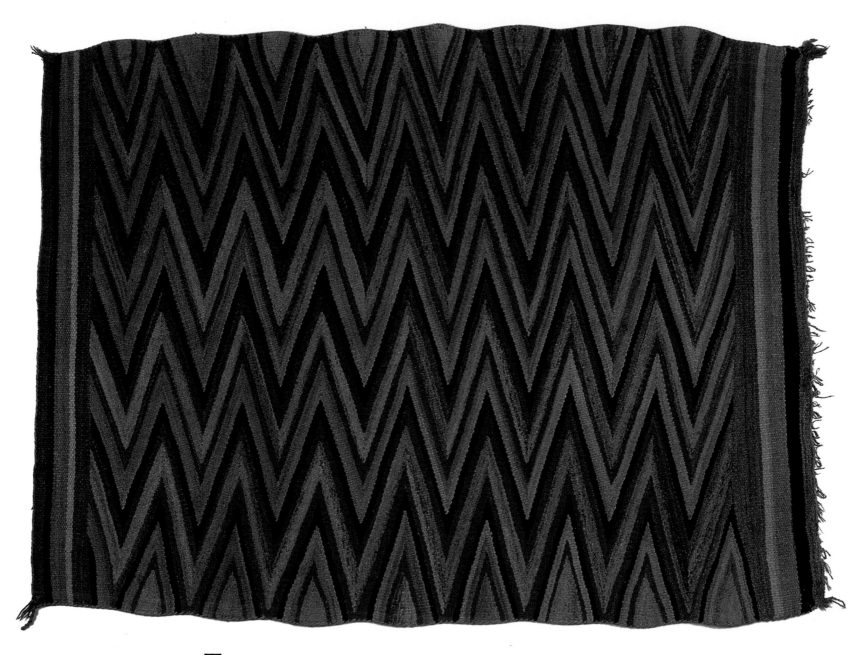

This Transition Period blanket (late nineteenth-century) features an unusual "pulled warp" or "wedge weave" technique. The angled, zigzagging patterns have been produced by battening the weft yarn down at alternating angles, resulting in diagonal rather than horizontal stripes. Repeating narrow black stripes stand out from those in red, grey, yellow, and brown.

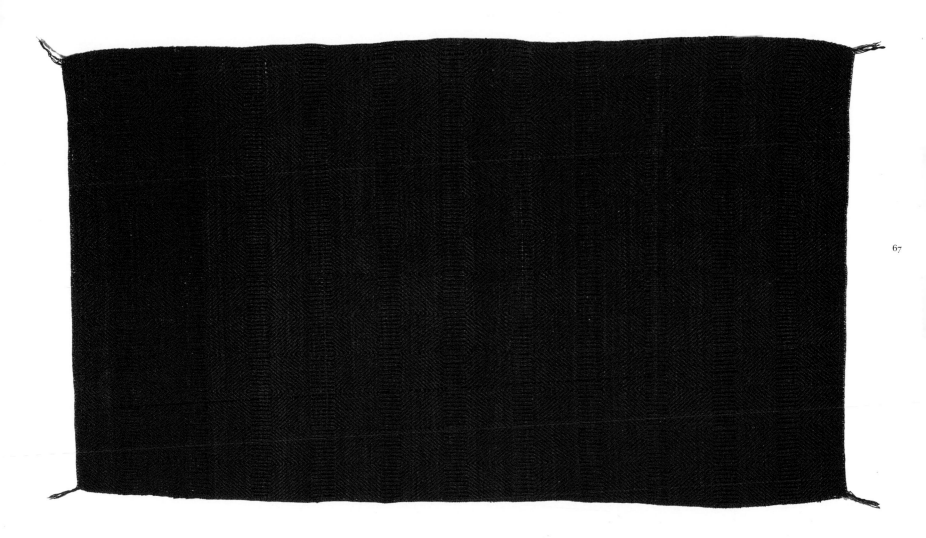

Although most Navajo blankets are woven in plain weft-faced weave, some, like this twentieth-century piece, are twill woven (over-two, under-two, the visible warp moving diagonally). The symmetrical red and black patterns are created by the weaving technique itself. Twill-woven blankets are more dense than other Navajo weavings, and are often still used by the Navajo as saddle blankets.

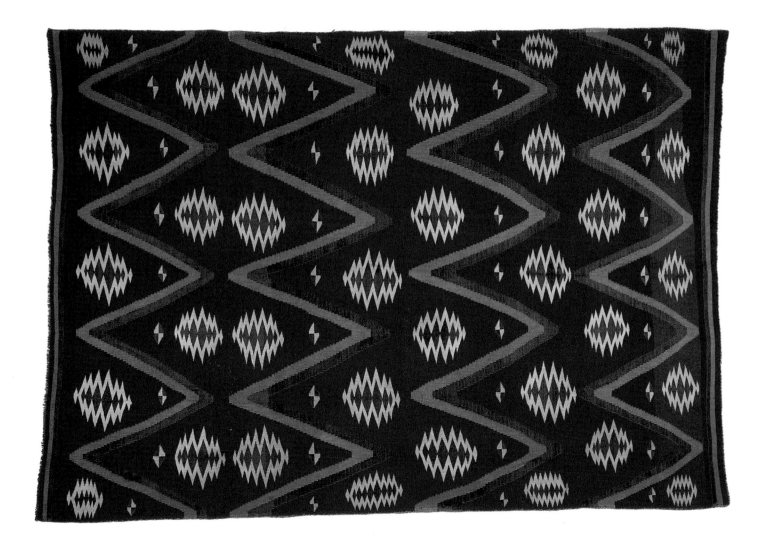

This red-background commercially dyed blanket of indeterminate date is unusual and has a charm all its own because of a lack of symmetry. Each blue and white serrated diamond motif sits in an angle of a zigzagging blue and green terraced band, but as the angles of the band on the right are opposed to those of the other bands, these two rows of diamonds sit in groups of two rather than staggered like the rest. Tiny four-part diamonds accompany the larger ones.

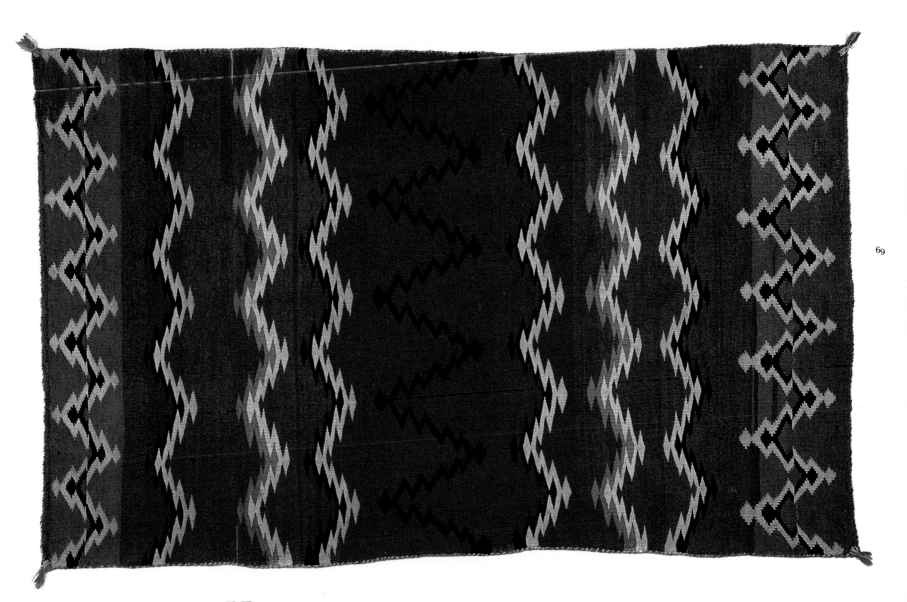

Harmonious though its motifs are unevenly spaced, this simple blanket, circa 1890, features a variety of types of zigzagging lines in yellow, blue, white, and green on a red background. The central pattern is a single color while the remainder are two-colored, the zigzags increasing in complexity as they move toward the outer edges of the blanket.

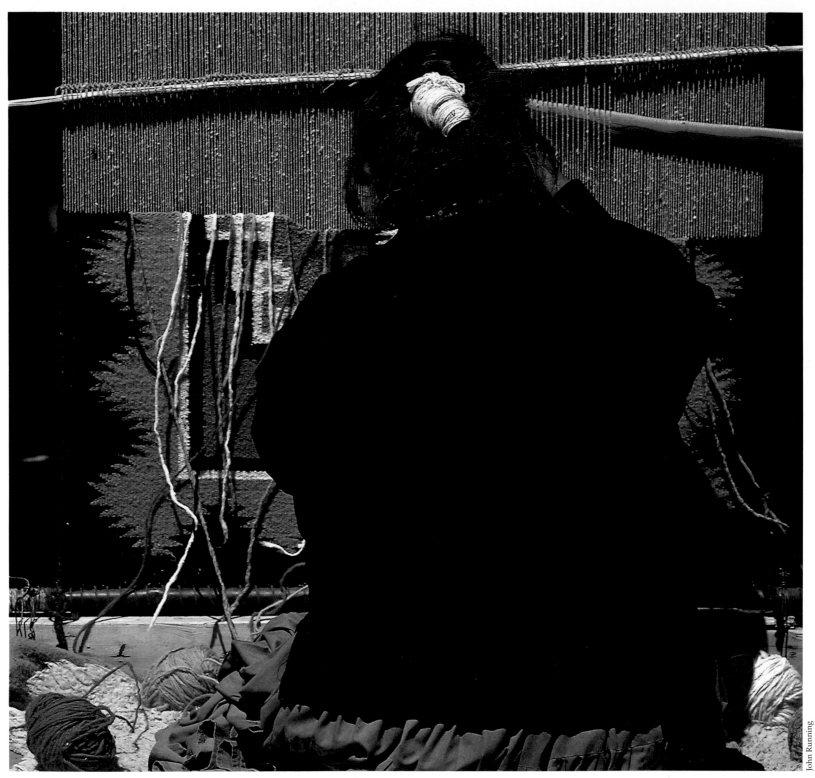

John Running

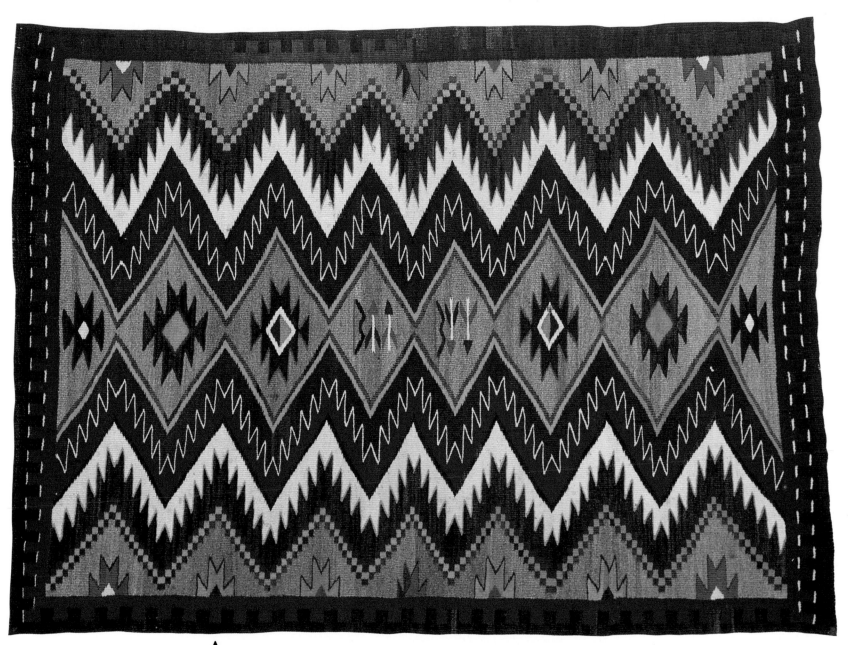

A typical Teec Nos Pos weaving of the early twentieth century, this elaborately patterned rug, probably naturally dyed, features two bands of multiple zigzags in red, maroon, white, black, and yellow on a grey ground with floating diamonds in the angles at the edges and in the central space and two tiny sets of bows and arrows in the middle of the rug. The piece features the picture-frame border typical of twentieth-century Navajo weaving and not found in earlier pieces.

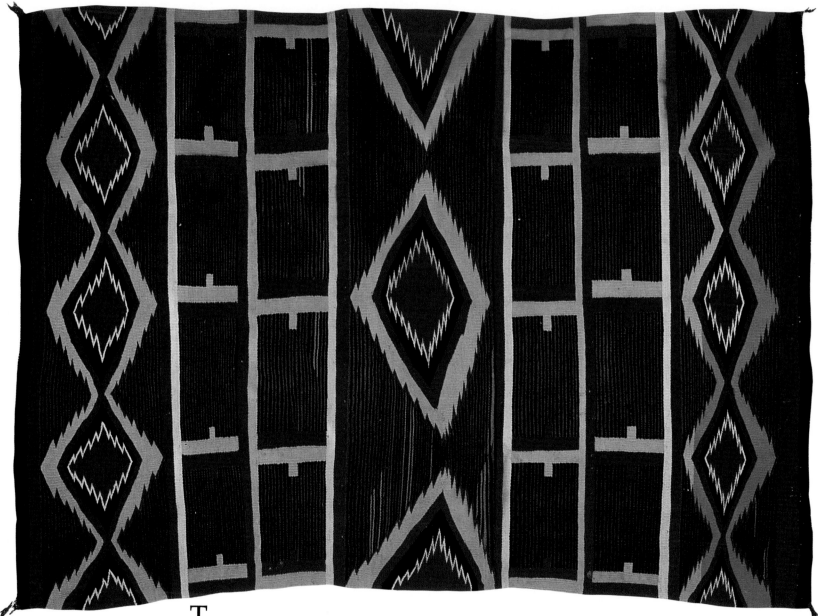

This Transition Period blanket, circa 1900, is woven in the "Moqui" pattern (an old name for Hopi, which dealers mistakenly applied to such Navajo pieces). Moqui-pattern blankets are characterized by narrow alternating stripes with large superimposed geometric shapes. The fact that these stripes are purple and black rather than the usual blue and black suggests that this blanket may have been woven at Ganado under the direction of trader Juan Lorenzo Hubbell. The large geometric designs in yellow, red orange, and white float above the stripes, unrelated to them.

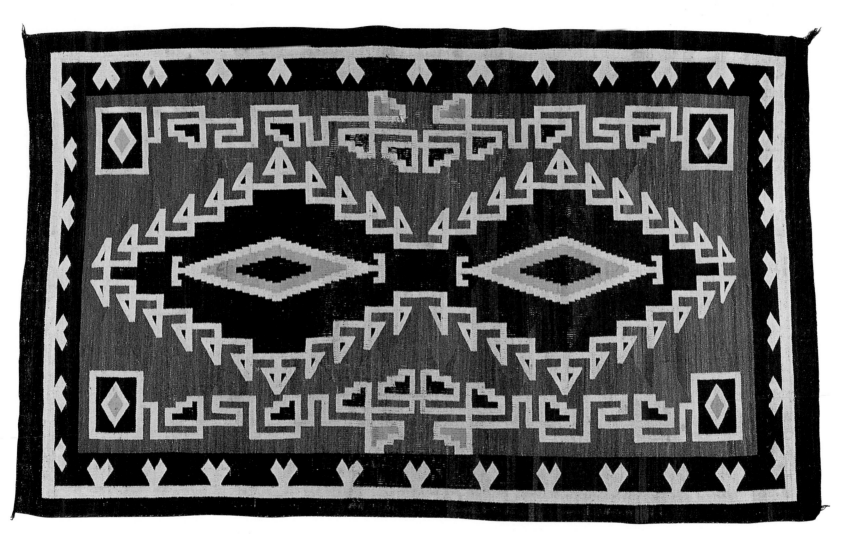

A typical Two Grey Hills rug, this handsome piece features the natural black, grey, tan, and white colors, oriental-inspired symmetrical design motifs, and technical mastery that characterize these most highly prized of Navajo rugs. Two concentric stepped diamonds are outlined by white geometric scrolls, with elaborate geometric scrolls above and below them, the whole enclosed in a black border from which pronged motifs extend.

74

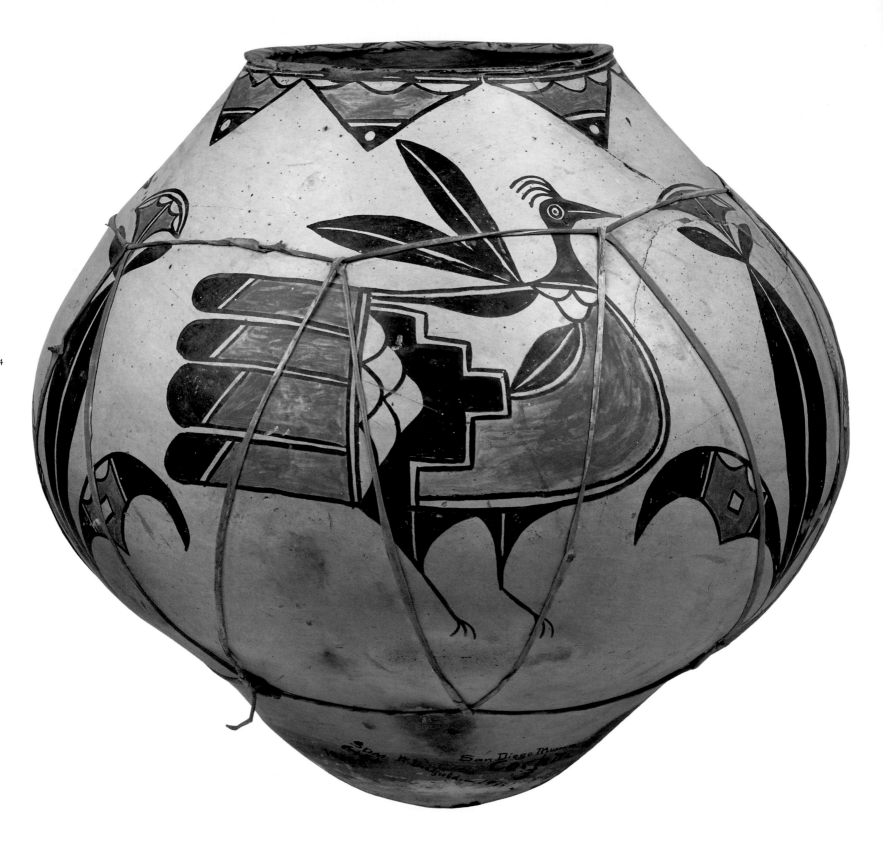

THE
CERAMIC
TRADITION

Tumacacori, Arizona; (*facing page*) excavated Zuni bowl, circa 1800–1825

POTTERY

THE CERAMIC TRADITION

BY JONATHAN BATKIN

The making of pottery in the Southwest dates back more than two thousand years, and study of it has probably generated more literature than any other aspect of Southwestern culture. Volume after volume has been published about the hauntingly beautiful ceramics of the Mimbres and other cultures, but study of prehistory cannot put us in touch with potters and their motives. Study of the historic period provides the most insights into the roles of potters and pottery, especially in the pueblos of New Mexico. Direct accounts and observations of the past four centuries, collections made among the Pueblos, historic archaeology, and early Spanish documents provide a wealth of information on which to base an understanding of this craft.

A great many factors affect a potter's final product: her experience, the specific tradition that guides her hands in shaping and decorating, the physical qualities of available clay and paints, and the temperature of the fire she builds. Shape, color, design, and choice of motifs vary tremendously from one village to the next, and these serve as marks of identity. When a potter marries into or moves to another pueblo, the style of the new home will usually be adopted; there are known instances in which potters of a former home have objected to copying of their style elsewhere. Despite the faithful perpetuation of differences, the same basic materials and techniques have been used in all of the pueblos.

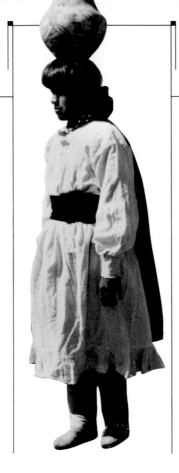

The principal ingredients of Pueblo pottery—clay and temper—are usually gathered within a short distance from the potter's home, although at times raw materials are traded. Temper is the nonplastic material added to clay to control or prevent shrinking and cracking. Sand, crushed rock, or crushed potsherds have all been utilized; in some cases several temper types have been used in a single village, the choice dictated by local tradition and the function of the ceramic. Clay and temper might be winnowed like wheat or sifted in order to remove undesirable matter such as twigs and rocks; they might be ground to fine powders with the *mano* and *metate*; or they might have little preparation before being mixed with water.

Simple hand modeling is used to shape small vessels and figurines. The technique for making larger vessels is called "coiling and scraping." The potter, having modeled the base of a vessel, sets it into a tray or mold, often called in the literature by the Tewa name, *puki*. This supports her work and allows her to turn it while she pinches long strands, or "coils," of clay onto the edge of the growing vessel. The addition of each coil increases the pot's dimension by an inch or so. When a rough shape has been achieved, the potter takes a fragment of gourd and, working quickly but carefully, shapes the pot. She presses the walls out from the inside and constricts shoulders from the outside, thins the walls, and obliterates the junctions between coils, ensuring a good bond and a strong vessel.

The surface of the pot is smoothed with a gourd fragment or other object. In modern times, tops of tin cans, kitchen knives, or popsicle sticks have been used; today, surfaces are often finished with sandpaper. When the pot has dried, the surface is partially or entirely covered with one or more slips— thinly dissolved clay solutions—applied with rags or pieces of wool. The slips are polished, often by rubbing with a smooth stone, before the pot is painted. At some pueblos mineral paints are used, and at others, vegetal (carbon) paints, but the same brush is used in all the pueblos. This is the tip of a yucca leaf, prepared by chewing to separate the fibers, then cut to the required width. A design might

This woman of Cochiti, circa 1911–1913, is carrying an olla, or water jar. Since about 1700, water jars have been made with an indentation to facilitate carrying on the head, although this trait dates much earlier in some pueblos. Formerly, round-based jars were balanced with the aid of a woven basketry ring.

be started by first laying the brush or other measure over the top of the pot, dividing it into equal segments; or the potter might simply start at one point and complete the design piecemeal.

Pottery is fired in an extremely simple "kiln." Unfired pots are inverted on a grate or sheet of metal that separates them from the ground. They are usually surrounded with pieces of broken pots or sheets of metal to prevent burning fuel from coming in contact with them, which would otherwise produce dark smudge marks on the surface. (Because some potters use electric kilns to fire their pottery today, collectors who seek purely "traditional" pieces sometimes look for smudge marks as proof of firing in the old manner.) Compacted manure is the most common fuel, although wood has been used, and among the Hopis, coal. The blocks of manure are stacked around the pottery and ignited, and when firing is complete, pots are removed and wiped off. Temperatures of 1700 degrees Fahrenheit have been measured in Pueblo kilns.

An important variation in firing is intentional smudging. After the fire has reached maximum temperature, it is smothered with pulverized manure or straw, creating dense smoke that impregnates the surface of the pots with carbon, turning them black. This technique has been practiced for centuries, but some contemporary potters have developed a successful new twist: The narrow flame of a propane torch is applied to the rim or body of a smudged pot to fire out the carbon, resulting in a combination of black and sienna.

Ritual has traditionally been an important aspect of pottery making, although it is apparently not observed by all contemporary potters. Mother Earth embodies a spirit, and her permission must be requested before she can be dug. According to W. W. Hill's ethnography of Santa Clara Pueblo, the people there believed that sickness would result if clay was gathered without the appropriate ritual. Cracks or breakage in pottery during drying or firing were considered a product of "technical ineptitude rather than ritual breach." Many historic Pueblo pots have the equivalent of the spirit path or spirit line often found in Southwestern baskets and textiles.

78

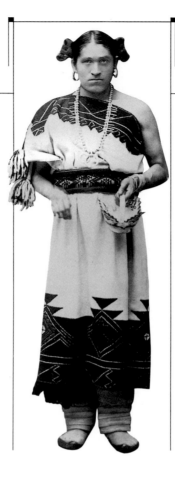

Some have called the discontinuity in encircling lines or bands a "line break," or "ceremonial break." At Zuni, the name for this is the same as the word for "road," similar to the English use of "path" or "road" to indicate the span of life. The line is left unjoined according to one potter, because "When I finish it, I shall finish my road," interpreted by Ruth Bunzel to mean "end my life." Not all potters observe this—the line break appears as religiously in some potters' work as it is lacking in others'.

One of the only examples of ritual ever recorded was observed by Frank Hamilton Cushing at Zuni in the 1880s. This was observed during the construction of a small canteen, said to be made in imitation of a human breast:

When a Zuni woman has completed the me' he ton *nearly to the apex, by the coiling-process, and before she has inserted the nozzle . . . , she prepares a little wedge of clay, and, as she closes the apex with it, she turns her eyes away. If you ask her why she does this, she will tell you that it is* a'k ta ni *(fearful) to look at the vessel while closing it at this point; that, if she look at it during this operation, she will be liable to become barren; or that, if children be born to her, they will die during infancy; or that she may be stricken with blindness; or those who drink from the vessel will be afflicted with disease and wasting away!*

Pottery is generally regarded as a woman's craft, although it seems to surprise nobody that many contemporary potters are men. This is only right, because research from several pueblos shows that men's participation in the craft is ancient and widespread. San Ildefonso serves as a good example. In his book *Maria*, Richard Spivey notes that Maria Martinez stated in 1977 that men had painted pottery at San Ildefonso for a "long time." In separate accounts, Maria and others have mentioned the names of at least fifteen who decorated pottery there before 1940. Among these were prominent men, some of them active in 1890 or earlier, for example Weyima (Antonio Domingo Peña), a guide and informant for the famous anthropologist Edgar Lee Hewett. Maria Martinez identified not only Weyima, her grandfather, as a pottery painter, but

The Zuni man-woman Wewha was both a weaver and potter. Wewha was also a religious leader and served as an informant for Matilda Coxe Stevenson and other anthropologists. He presumably made his clothing and the ceremonial ceramic he holds in this photograph, which was taken in the late 1880s.

her father, Tomas Montoya. One adopted Navajo was also a pottery painter at San Ildefonso. This was Santiago Martinez, father of both the great potter Tonita Roybal and painter Crescendo Martinez.

Men-women were also active as potters. These were male transvestites who, from an early age, adopted women's dress, habits of speech, and chores. The most famous man-woman was the Zuni, Wewha, an important informant for Matilda Coxe Stevenson who, with her husband James, was a pioneer anthropologist in the Southwest. She referred to Wewha as "the strongest character and the most intelligent of the Zuni tribe within (her) knowledge." From Stevenson's accounts, Wewha's notion of self was clearly as a woman, and Stevenson sometimes referred to him as "she." Wewha was a weaver, as men traditionally were in the pueblos, but also a potter. In fact, Stevenson claimed that he and another man-woman were the two greatest potters at Zuni when she worked there. Stevenson's account of Wewha gathering clay is the finest:

On one occasion Mr. Stevenson and the writer accompanied We'wha to Corn Mountain to obtain clay. On passing a stone heap she picked up a small stone in her left hand, and spitting on it, carried the hand around her head and threw the stone over one shoulder upon the stone heap in order that her strength might not go from her when carrying the heavy load down the mesa. She then visited the shrine at the base of the mother rock. When she drew near to the clay bed she indicated to Mr. Stevenson that he must remain behind, as men never approached the spot. Proceeding a short distance the party reached a point where We'wha requested the writer to remain perfectly quiet and not talk, saying: "Should we talk, my pottery would crack in the baking, and unless I pray constantly the clay will not appear to me." She applied the hoe vigorously to the hard soil, all the while murmuring prayers to Mother Earth. Nine-tenths of the clay was rejected, every lump being tested between the fingers as to its texture. After gathering about 150 pounds in a blanket, which she carried on her back, with the ends of the blanket tied around her forehead, We'wha descended the steep mesa, apparently unconscious of the weight.

79

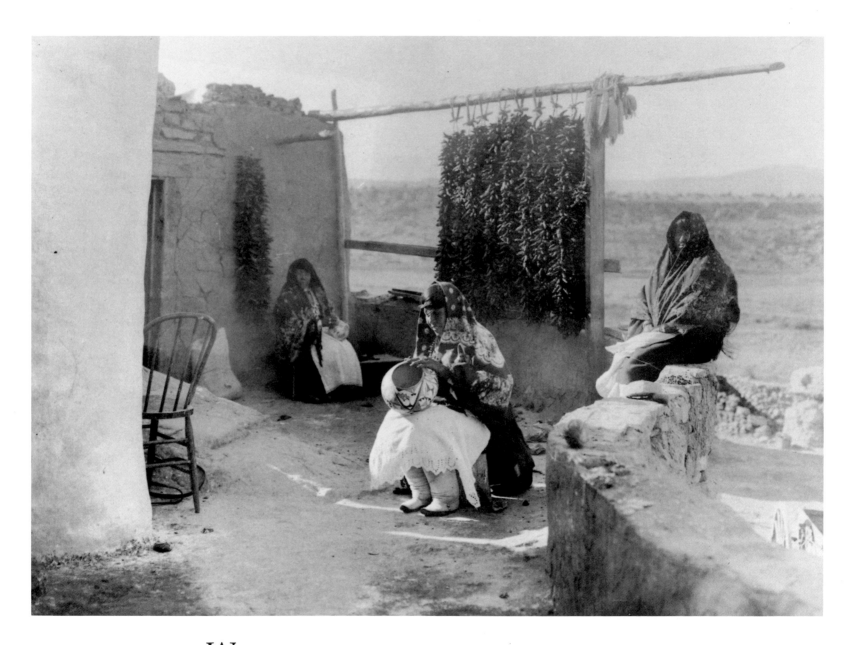

Wrapped in shawls, these women of Acoma or Laguna, circa 1910, apparently posed during the winter. Pottery making is a year-round activity in the pueblos, although more actively pursued in warmer months. Opposite: This view of Zuni, photographed in 1879, faces northeast toward Corn Mountain. Ceramic jars, with their bases knocked out, stacked, and plastered once commonly served as chimneys.

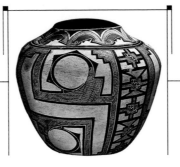

Tsayutitsa, a master potter of Zuni, made this superb storage jar in 1939. Typical of her work, the design is carefully placed and flawlessly executed. Few potters of the twentieth century have excelled in both the making of huge vessels and painted design.

Wewha was not unusual. Transvestite potters in the pueblos of New Mexico can be traced back more than 150 years, and they likely occupied a role that existed for centuries.

Continuity and innovation of design in pottery pose different problems than in basketry or textiles. Both of those crafts appear to have changed quite slowly in the pueblos, at least until within the past century. Authors have often commented on conservatism in the pueblos, pointing to such things as traditional costume and the fact that Pueblo women abandoned it so much later than among other Southwestern tribes. However, conservatism does not characterize Pueblo pottery in the historic period. If the archaeological record did not prove otherwise, ceramics made in a single pueblo only one hundred years apart might be identified as foreign to each other.

Pottery has changed rapidly since the Spanish conquest, even though potters always turn to the work of their teachers for design inspiration. Zuni Pueblo, for example, demonstrates this change. The sheer quantity of pottery from Zuni provides a clear picture of style development from about 1700 to 1900. Imagine the situation there in 1879, when the first anthropological studies began at the pueblo. John Wesley Powell had given orders to James Stevenson to collect among the Pueblos, and there was Zuni, literally overflowing with pottery. Stevenson and his co-workers collected hundreds of ceramics at Zuni in 1879, and continued collecting for the next five years. One of these collections—and just pottery—numbers 2,250 pieces. Collections such as this, together with historic examples recovered archaeologically, help us understand the mechanics of change.

What we learn is that Zuni potters were fond of innovation. So fond, in fact, that the number of ceramic types made there in the 1870s is probably as great as the number of types made in all other pueblos combined. As in other pueblos, Zuni pottery of the mid-1700s is radically different from the pottery of the mid-1800s, yet each successive style is based on a preceding style, differing not much, and gradually becoming more and more distant in concept.

The Zunis were also fond of copying old ceramics. Deliberately archaic pieces are often stumbling blocks for the researcher. These might appear to have been recently made when collected, but are in a style that was a hundred or more years old at the time.

For decades before Stevenson collected at Zuni, potters were surrounded by hundreds of pieces, each different from the next, yet each typically Zuni. Each offered a bit of inspiration for new combinations of popular motifs, or perhaps suggested something entirely new. The repertoire of designs was immense, and the tradition strong. However, when Stevenson removed more than 5,000 ceramics from the pueblo in a five year period, the Zuni ceramic tradition collapsed within twenty years. A few popular styles continued; but whereas the pottery of 1880 was not much different from the pottery of 1860, the pottery of 1900 was radically different from that of 1880, and not much was made. Change in the ceramic tradition, of course, was nothing new. The technology of pottery was imported from what is now Mexico, and styles had evolved, been abandoned, recombined, and blended for centuries.

Pueblo pottery gained the admiration of some of the early Spanish visitors to the Southwest. Yet as much as the Spanish were impressed with the quality and beauty of the pottery they encountered in the sixteenth century, they were to be responsible for significant changes in the tradition. Change after Spanish contact was different from before. Potters gained inspiration from design systems of another world—the Old World, as we still call it—and took advantage of new markets and marketing techniques.

Conditions were so bad during the first century of Spanish occupation that dozens of pueblos were abandoned. Increasing tension led to a revolt in 1680, in which the Pueblos drove the Spanish from the region, destroying the mission churches and homes of the colonists. In 1692 the Spanish returned to reconquer, and by 1696, the Pueblos were again under Spanish control. Prior to the Pueblo Revolt, the Spanish exacted tribute in textiles and grain. No record shows that pottery was paid in tribute; how-

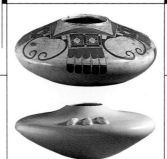

ever, the Spanish relied almost entirely on the Pueblos for pottery and strongly influenced the craft, both directly and indirectly. At the time of Spanish contact, potters of several pueblos decorated vessels with glaze paints. During Reconquest, this practice halted because the Spanish gained control of the region's mineral resources, including the lead salts needed for glazes. After Reconquest, coexistence was considerably more peaceful and the Spanish relaxed some of their control. Nevertheless, Spanish presence increasingly affected Pueblo pottery.

The most obvious evidence of Spanish influence in the early historic period is the occurrence of new, nontraditional pottery shapes, both domestic and ecclesiastic. From excavations in the mission churches, eighteenth century inventories of the missions, and other accounts can be established the existence of Pueblo-made ceramic chalices, baptismal fonts, holy water bowls, candlesticks, and incense boats, censers, and spoons. Examples have been recovered from the ruins of several missions, and their early presence in others has been documented. One common European introduction is the soup plate, which appears in the archaeological record in the seventeenth century. Many examples have ring bases, or "feet," to imitate manufacture on the European potter's wheel.

To understand some domestic forms that appeared in the past two centuries, the Pueblo diet and Pueblo economy should be considered. At the time of Spanish contact, the Pueblos cultivated corn, beans, squash, tobacco, and cotton. Among the foods known to have been consumed were a variety of preparations from ground cornmeal, including puddinglike mushes, the paper thin bread commonly known among Anglos today by the Hopi name *piki, tortillas* fried upon the *comal* (stone or ceramic griddle), and small dumplinglike breads, sometimes cooked by burying in hot ashes.

Among the many foods the Spanish introduced was wheat, which came to rival corn as a staple. Some of the earliest accounts of wheat in the region are references to plots of land cultivated by the Indians for the missions. Apparently, in the late eighteenth century, much of the wheat was raised by the

The flattened jar shape of fifteenth and sixteenth century Hopi pottery, best known from the ruins of the village of Sikyatki, has been emulated by a few indefatigable potters. Top: *A Sikyatki Revival jar by Nampeyo, circa 1905–1910. Nampeyo, of the village of Hano, descended from Tewa Pueblos who fled to the Hopi villages during the Spanish Reconquest.* Bottom: *A contemporary interpretation by Al Qöyawayma. The corn designs are pressed out from the interior.*

Indians to sustain the missionary, but Pueblo cultivation of wheat may have increased rapidly. When the missions of New Mexico were inventoried in 1776, quantities of wheat equalling corn production were noted, as well as outdoor ovens—examples of the *orno,* or beehive oven introduced by the Spanish. Accounts of travel in the nineteenth century do not clarify to what degree or when wheat became a regular part of the Pueblo diet. Certainly, corn *tortillas* and breads like *piki* are the most commonly mentioned, but there are references to leavened wheat bread.

Once the Pueblos began making leavened bread, they needed a vessel in which to make dough. The dough bowl is a vessel of large diameter and great depth, often with an upright or flaring rim. Survey of collections and archaeological data suggests that the dough bowl was rarely made in the eighteenth century, and did not become a common type until as late as 1825 to 1850. The reason for the growing popularity of wheat bread is unclear, although it may be as simple as the increasing presence of Anglo Americans after the opening of the Santa Fe Trail in 1821, and concomitant increased wheat production to satisfy their hunger for the grain. Today wheat bread is a popular food in the pueblos, commonly made on feast days.

The large spherical or vertical storage jar must also be associated with some economic change in the pueblos, for it seems to have become popular rather suddenly in the early nineteenth century. Eighteenth century sites have yielded few fragments of storage jars, if any, and no examples are found in museum collections with design systems that definitely predate 1800. Some of the oldest storage jars and fragments have been recovered from pueblos not where they were made but to which they were traded. Potters at Zia, for example, specialized in the making of large jars, and some of the finest have been collected at Jemez, which is not far away. However, Zia storage jar fragments were excavated at Pecos Pueblo, 45 miles distant as the crow flies. How ceramics this large were transported is unknown. The *burro* might have been used to carry pottery, or the Indians might have utilized the *carreta,* a simple

83

84

Taos, the last multistory pueblo, is still reverently maintained. In the words of one Taos man, which seem to reflect a universal feeling shared by the Southwest's native peoples: "We have lived upon this land from days beyond history's record, far past living memory, deep into the time of legend. The story of my people and the story of this place are one single story. No man can think of us without thinking of this place."

Harvey Lloyd

86

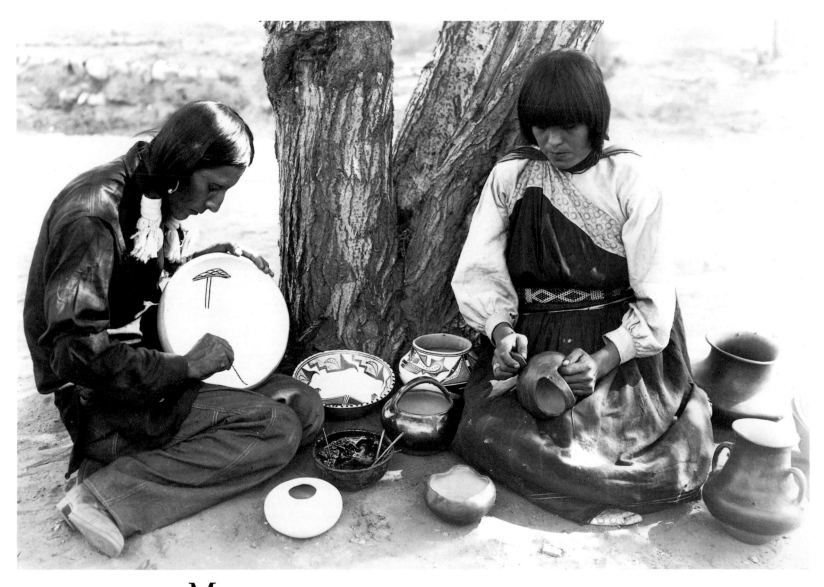

Maria and Julian Martinez of San Ildefonso demonstrate pottery making at the Palace of the Governors in Santa Fe. Julian was a novice painter when this photograph was taken in 1912; Maria became the single most famous native American artist. *Opposite: This potter of Acoma, photographed in about 1920, may only pretend to decorate a jar with a yucca brush—a pose commonly struck for photographers. The jars, tall-necked vase, handled "basket," and ashtrays are intended to satisfy the budget of every variety of collector and tourist.*

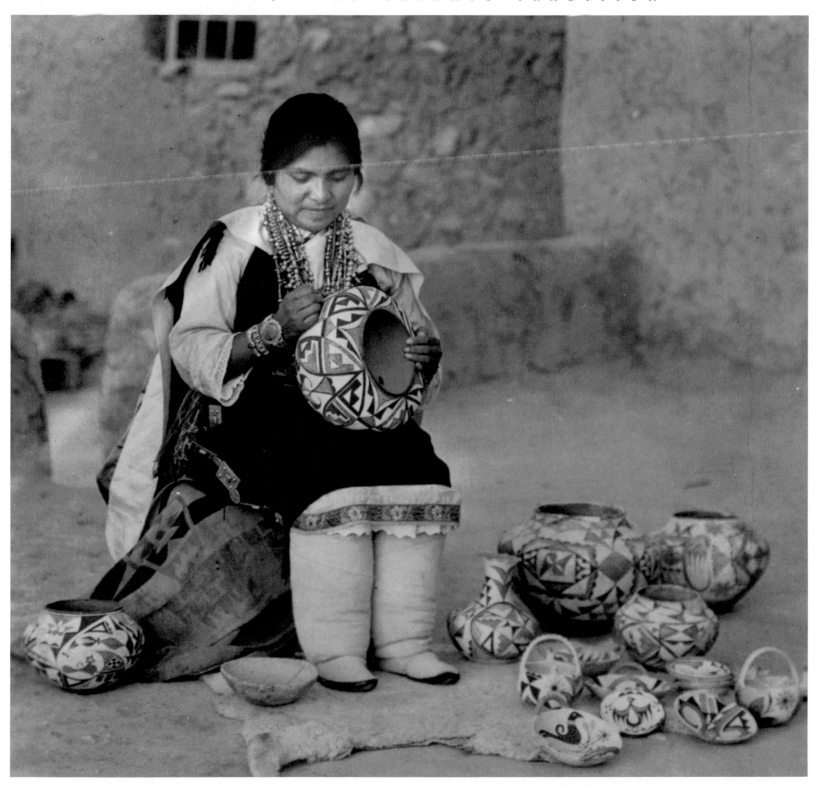

This ceramic figurine from Cochiti, circa 1880, depicts an Anglo on a stool with a small bird in his right hand. The inspiration for this and similar humorous pieces may have been circus entertainers.

two-wheel cart, which the Pueblos are known to have been making as early as the seventeenth century.

That the Pueblos traded storage jars great distances is clear, but if they were going to send them so far, why wouldn't they send something in them? Even though a potter need not have made a container of standard size for household use, the storage jar may have evolved as a standard measure. Study of storage jars indicates that the typical example has a capacity of approximately one half *fanega*. The *fanega*, a standard measure about the size of two and one-half bushels, was familiar to the Pueblos, who used it in early colonial times to measure the grain they paid as tribute to the Spanish crown.

Spanish-influenced painted design in Pueblo pottery is more difficult to demonstrate than foreign shapes. Pottery of the eighteenth century exhibits characteristics that are not logical developments from earlier styles. Potters began to use curvilinear elements and floral motifs, as well as an eight-pointed star that is clearly derived from Hispano-Moresque design. Somewhat later, probably in the first quarter of the nineteenth century, relatively naturalistic depictions of life forms, especially birds, became common. Although these developments have been considered indigenous by some, they are clearly the result of contact with the Spanish and others.

A logical source for pottery designs would be gaily decorative ceramics made in Mexico, Spain, and Asia, which have been recovered from many Spanish and Pueblo sites. The Indians may have sought out the fine, hard majolica and export porcelain. At Franciscan Awatovi, the mission at a Hopi village destroyed in 1700, excavations proved that only the most fragmentary majolica remained, leading the excavators to believe that the Indians had removed complete vessels to their homes; and a Chinese porcelain plate was recovered from a Reconquest era refuge site in extreme northwestern New Mexico. Majolica and other imported wares account for only a tiny percentage of ceramics at historic sites, but Pueblos certainly observed them.

Aside from a small quantity of pottery, the early Spanish settlers brought little with them that could have served as inspiration for pottery design. However, the Franciscan fathers enlisted Pueblo labor to build and decorate the mission churches of New Mexico and Arizona. Those traces of decorative elements that have survived are fascinating. Excavations at Awatovi show several examples of painted decoration from the mission. The builders had painted one wall in a pattern intended to mimic Spanish or Mexican tiles, and the face of the altar showed elaborate floral design. Similar evidence has come to light in excavations of other missions.

In addition to majolica, Mexican decorative arts exported to New Mexico include painted chests and patterned fabrics, among other things. The trade in such goods continued well into the American period, coming not only north from Mexico, but from Europe and the eastern United States via the Santa Fe Trail. Exactly what influence the Santa Fe Trail had on the ceramic tradition is unknown. In the late nineteenth century, Pueblo potters occasionally made peculiar pieces that seem surely to have been inspired by American glass or metal wares, and imported metal vessels gradually replaced pottery in some of the pueblos, contributing to the decline of the ceramic tradition.

The influx of Anglo traders after the Mexican War had obvious effects. Jake Gold of Santa Fe had a profound influence on pottery of Tesuque and Cochiti. One of Gold's specialties was ceramics, including small figurines. Gold's Provision House was the likely subject of this description made in 1881: ". . . a unique establishment devoted to the sale of Indian pottery, basket-ware, stone-hammers, Navajo blankets and other articles of their manufacture. A great deal of the pottery was obscene but kept concealed from ladies visiting the place." Gold advertised his specialization in pottery and, of course, had to have a ready supply. The pueblo nearest Santa Fe, Tesuque, lies only a few miles to the north, and most of the pottery in which Gold dealt was made there. Not only were potters at Tesuque making ceramic vessels and figurines for Gold, they produced such handy items as flowerpots, complete

88

Tonita and Juan Cruz Roybal of San Ildefonso never achieved the fame of Maria and Julian Martinez, although their work was as good, perhaps better. This beautiful jar of about 1939, polished red with matte red and white decoration, exemplifies one of their most innovative processes.

with drain holes. Gold also dealt in pottery from Cochiti, and one has to wonder if he did not show potters there the wares of Tesuque and *vice versa*, because the decorative systems of these pueblos became similar in the late nineteenth century. Interestingly, Gold probably helped the Tesuque ceramic tradition survive longer than it might have otherwise. Around 1900, when the demand for Tesuque pottery was declining, pottery made there became debased. Evidence suggests that one Tesuque potter who made exquisite, large pieces in 1880 made only trinkets in 1920.

The end of the nineteenth century brought about the demise of pottery making in most of the pueblos. The railroad to Albuquerque was completed by 1880, going near the pueblos of Santo Domingo, Isleta, Laguna, Acoma, and Zuni, and close enough to the Hopi villages to encourage droves of tourists to invade. Not wanting to carry back large water jars, storage jars, or dough bowls, they often preferred the little memento. There was money to be made, and the Pueblos were now reliant upon a cash economy. Consequently, old pottery types gave way to new, and the little figurine, basket-bowl, and ashtray became commonplace. Potters at several villages took advantage of the tourist industry to market pottery. Lagunas and Isletas often traded at the railroad stations, and at Acoma and its satellite villages, more than 75 women were listed as potters by profession in the 1910 census. Acoma is probably the only pueblo in which pottery never declined radically.

By the beginning of the twentieth century, efforts to revive the dying tradition were made. In 1907, the newly founded School of American Archaeology (now the School of American Research) began excavations in the canyon of the Rito de los Frijoles on the Pajarito Plateau, and Indians of San Ildefonso Pueblo were employed to assist. During 1908, Maria Martinez examined pottery sherds from the site, and with the encouragement of Edgar Lee Hewett, she and her husband, Julian, began experiments to reproduce the early wares of the Plateau. The museum purchased examples of Maria's and other potters' work, and made them available to anybody

with an interest. In time, with the encouragement of individuals such as Hewett and Kenneth Chapman, Maria Martinez and others became celebrities and achieved unprecedented financial success. Chapman, his associates, and various traders working independently were directly involved with pottery revivals at several pueblos, and at each at least one master emerged. Some of these potters are hardly remembered today, yet the pieces they made fairly cry out from museum shelves. The superior ceramics of Trinidad Medina of Zia, Tsayutitsa of Zuni, and Mrs. Ramos Aguilar of Santo Domingo are unmistakable.

Since the end of World War II, pottery making has flourished, and today numerous potters keep this ancient tradition alive, some of them preserving types made by their elders, some seeking new expressions, but all of them working with the same Mother Earth.

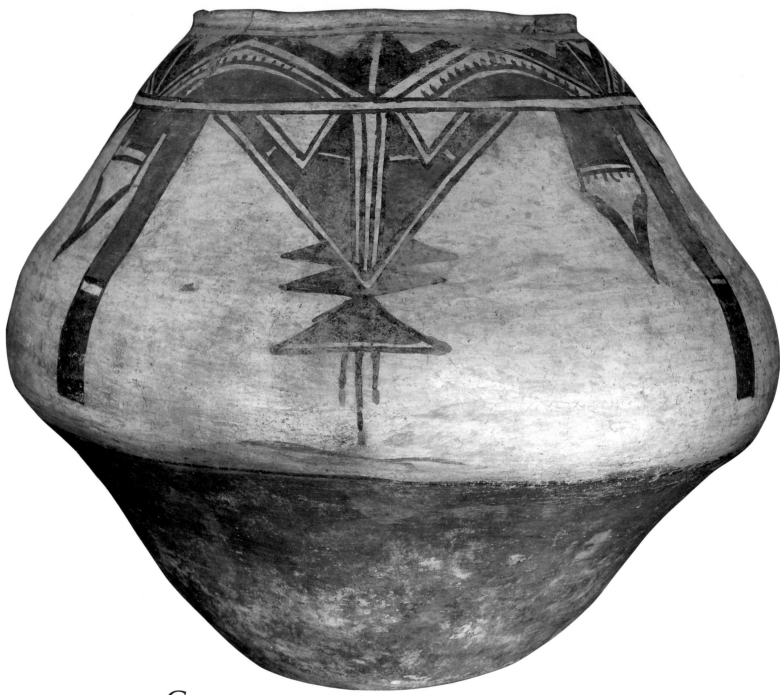

Complete Pueblo ceramics of the early eighteenth century are extremely rare. This water jar was made at Acoma before 1750 and was preserved there as an heirloom until collected in 1883. The shape, popular in the pueblos for nearly a century, is quite functional: A depression in the base facilitated carrying on the head; the bulge gave the pot a low center of gravity and the potter a handhold.

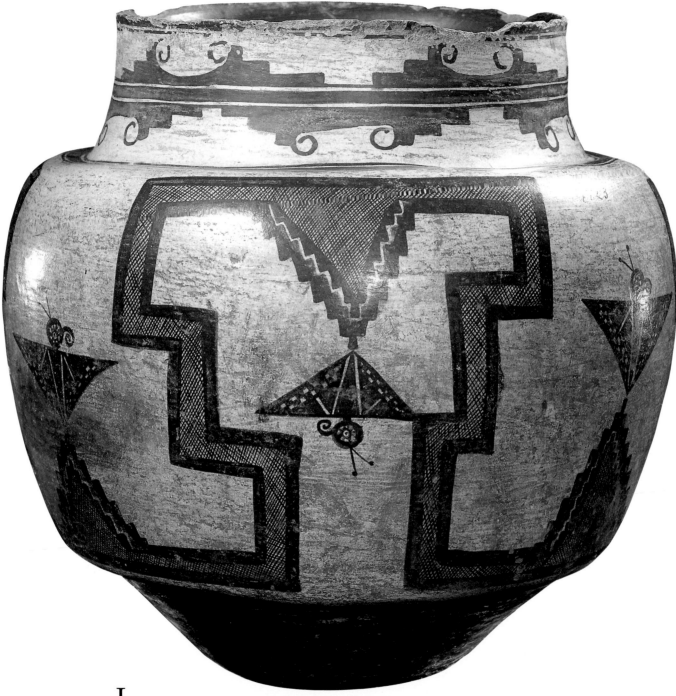

Life forms became common decorative motifs on Pueblo pottery in the nineteenth century, particularly at Zuni. Stylized birds and butterflies were popular there until the 1870s, when deer and antelope became predominant. This exquisite vessel, probably made between 1825 and 1840, is one of a mere handful that have survived from that period.

92

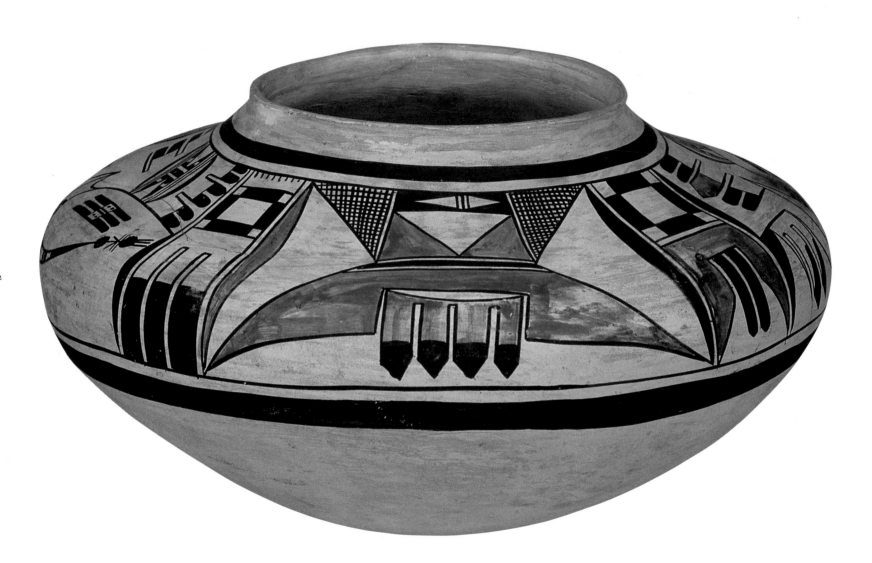

Nampeyo, of the village of Hano, was the first Pueblo potter to gain wide recognition. She received encouragement from trader Thomas V. Keam, as well as her husband, Lesou, who brought her fragments of ceramics from the ruins of Sikyatki, where he worked for archaeologist Jesse Walter Fewkes in the 1890s. Seeking forgotten sources of clay and reviving old techniques, Nampeyo mastered ancient Hopi styles. This jar, made in 1901, shows the stylized feather motifs typical of ancient and revival pottery.

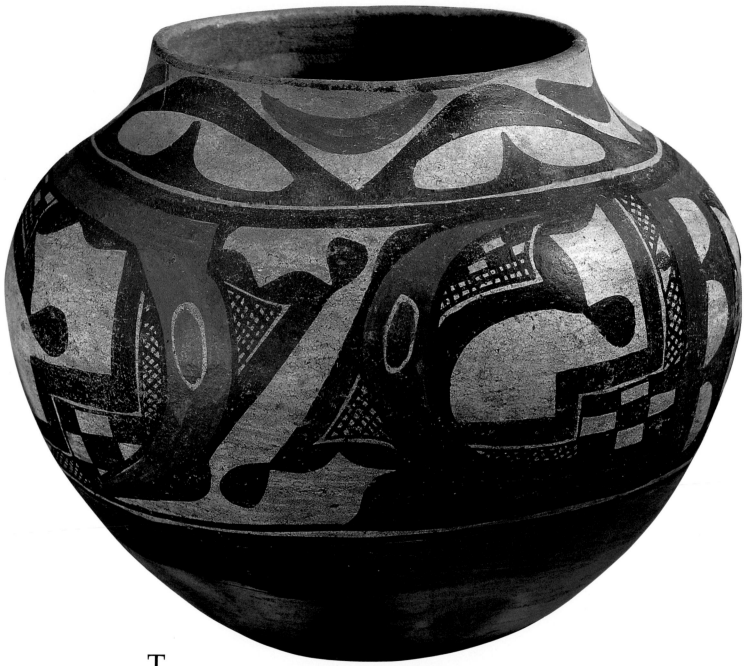

The simple, blocky decorative style on this water jar, devoid of Spanish-derived flowers and animals, is unmistakably that of Santa Ana Pueblo. One visitor to Santa Ana in 1881, about the time this olla was made, noted the excellence of pottery there. By 1900, few potters were active, and today, such fine old vessels are scarce.

94

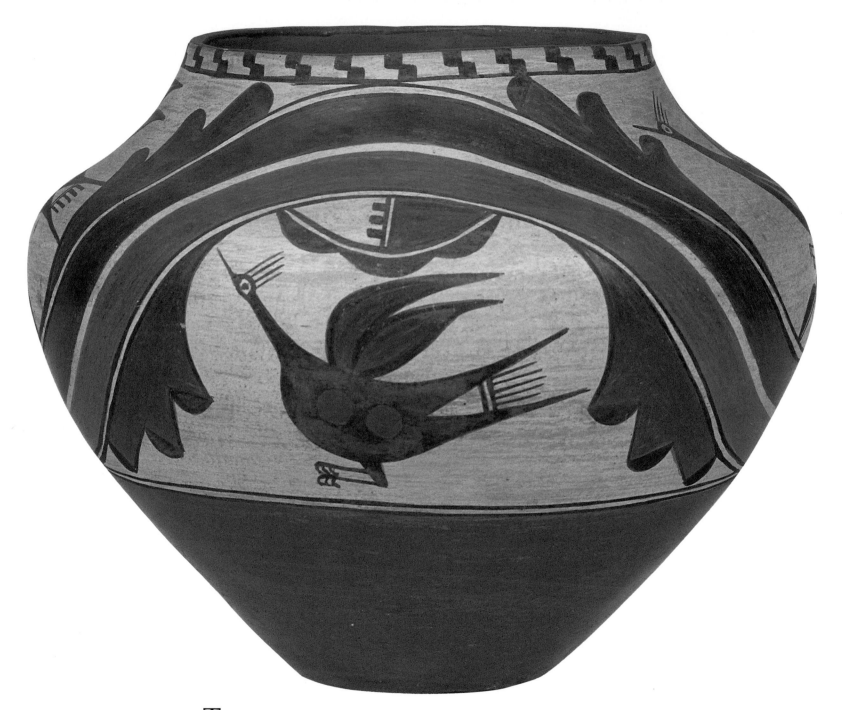

Trinidad Medina of Zia, although practically forgotten today, was highly regarded in the 1930s and 1940s, when she travelled the country demonstrating pottery making. Like Tsayutitsa of Zuni, Medina is one of few twentieth century potters to attain mastery of huge forms and painted design. This olla, *made about 1940, is one of her finest efforts.*

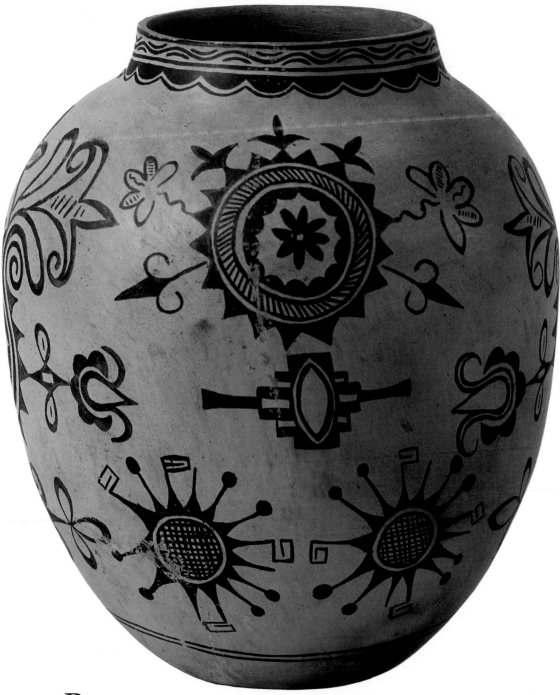

Pottery making at Tesuque flourished in the late nineteenth century due, in part, to the marketing of this pueblo's pottery by Jake Gold and other Santa Fe dealers. This storage jar by Katherine Vigil, circa 1880, illustrates Tesuque's style at its finest—floral and geometric motifs of Spanish origin float freely, independent of borders.

96

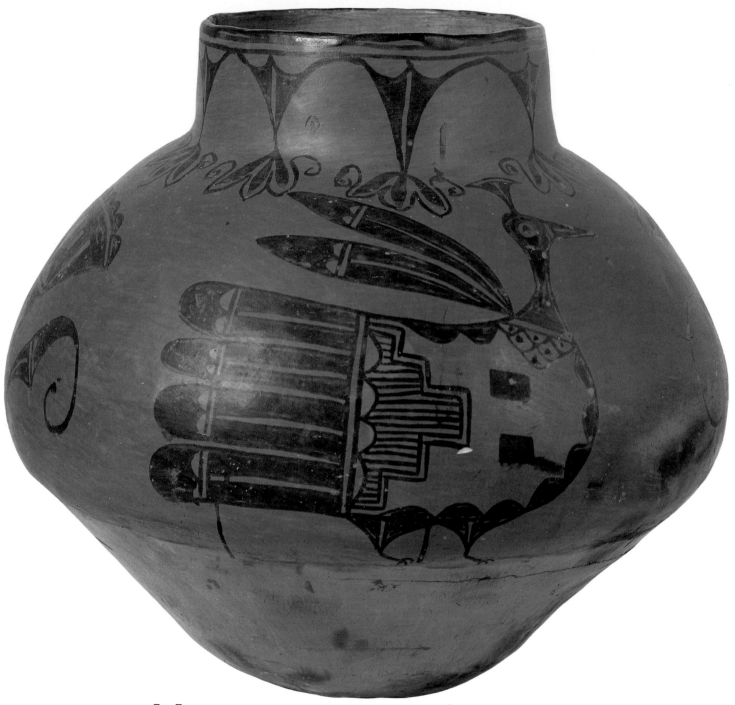

Martina Vigil and Florentino Montoya of San Ildefonso were experienced potters when they moved to Cochiti early in this century. This storage jar, and another on page 74, are among their finest, made between about 1905 and 1910. Florentino's painting style is unmistakable; majestic birds are composed of disparate elements, including clouds.

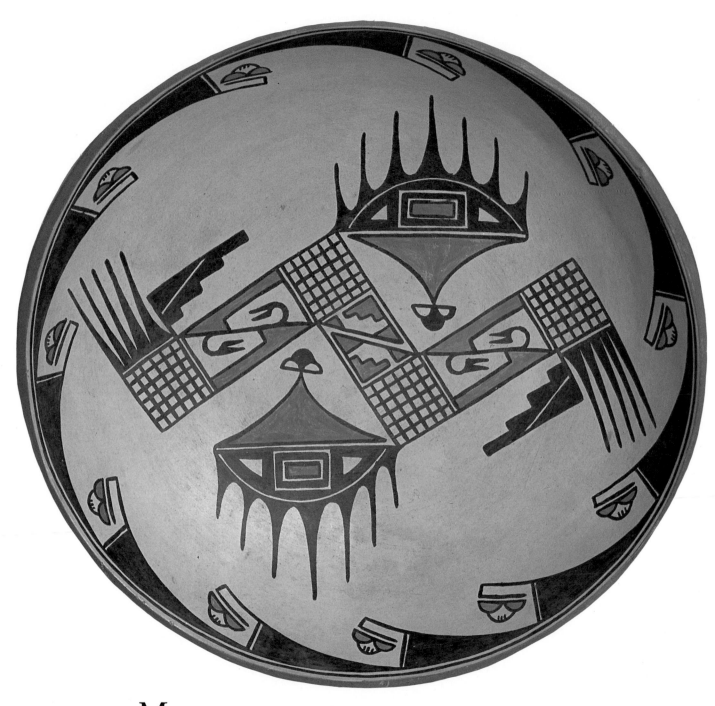

Maria and Julian Martinez were masters of many types of pottery, although they are best known for polished black vessels with designs in matte black paint. Practicing on pottery and in watercolors, Julian had become a talented painter by 1920, about the time that this exceptional bowl was made. The design may have been drawn from Julian's imagination, although his son Adam identified it as sacred.

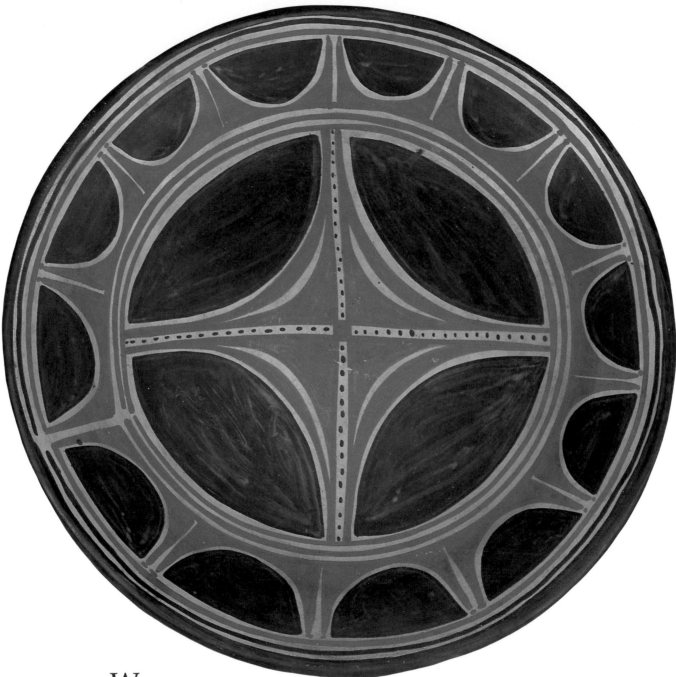

98

W hen Santo Domingo pottery sales began to decline in about 1905, Julius Seligman, proprietor of the Bernalillo Mercantile Company, approached three potters hoping to revive the ailing craft. The two sisters and their sister-in-law, Mrs. Ramos Aguilar, invented a new style—white slip showed through black and red paint only as small negative spaces. They mostly produced water jars; this bowl, probably made by Mrs. Aguilar in about 1915, is one of few known to exist.

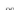

The dough bowl is not an ancient vessel among the Pueblos, but an historic development to accommodate the kneading and rising of Spanish-introduced leavened bread. Exterior designs almost never vary on old examples from some pueblos, particularly Zuni and Zia, where this was made in about 1880. The meaning of this pattern is unknown, although the design used at Zuni, which is similar, has been said to be symbolic of a prayer.

100

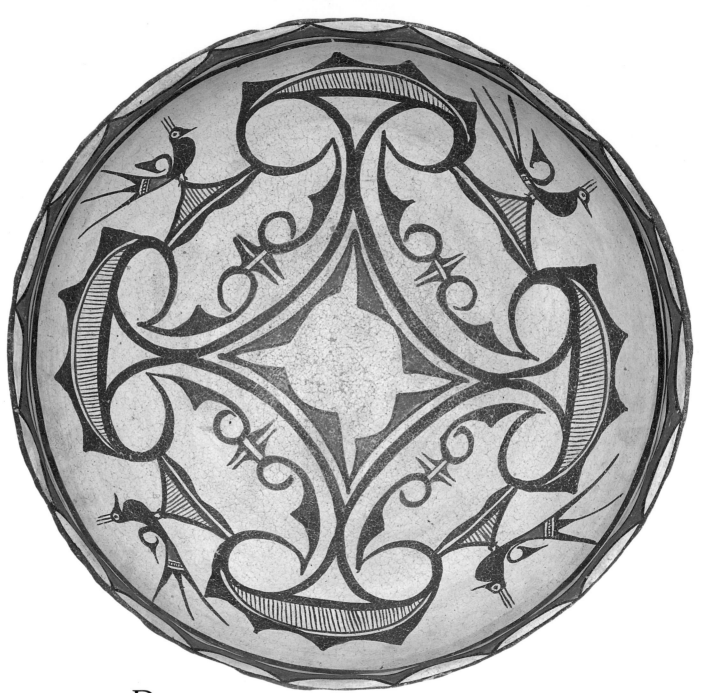

Dough bowls from most pueblos have undecorated interiors, perhaps because use obliterates designs. However, many examples from Zuni with poorly executed, repetitive designs on their exteriors are beautifully painted on the inside. This bowl from the late nineteenth century is decorated with motifs adapted from water jars.

This huge, elegant dough bowl, a modern expression made in about 1935–1940 by Margaret Tafoya, incorporates difficult techniques and ancient symbolism. Smudged, polished black pottery is a specialty of Santa Clara, but few potters make large vessels, for they must be polished quickly and without interruption. The bear paw, a design dating to late prehistoric times, symbolizes a legendary bear that led the Santa Claras to water during a drought.

The hunter's canteen (facing page) from Zuni, made in about 1880, is unusual for the depiction of dragonflies—a Zuni water symbol usually restricted to ceremonial ceramics. A hunter would have carried this large canteen by wrapping it in a blanket and tying it to his back. Above: This ceremonial ceramic drum, made by Tsayutitsa of Zuni in 1928, is decorated with three antelopes with "heart-lines." Often painted on Zuni pottery, these are said to represent prayers to the spirits of the animals to reveal themselves to hunters. Drums, made with thick walls and exaggerated lips to allow attachment of drumheads, are known only from Zuni, and do not appear in the archaeological record.

Bibliography

PREHISTORIC SOUTHWEST

Ambler, J. Richard. 1977. *The Anasazi.* Flagstaff: Museum of Northern Arizona Press.

Berlant, Tony, Steven A. LeBlanc, Catherine J. Scott, and J. J. Brody. 1983. *Mimbres Pottery: Ancient Art of the American Southwest.* New York: Hudson Hills Press.

Brody, J. J. 1977. *Mimbres Painted Pottery.* Albuquerque: University of New Mexico Press.

Haury, Emil. 1976. *The Hohokam Desert Farmers and Craftsmen: Excavations at Snaketown, 1964–65.* Tucson: University of Arizona Press.

LeBlanc, Steven. 1983. *The Mimbres People.* London: Thames and Hudson.

Lister, Robert H., and Florence C. Lister. 1978. *Anasazi Pottery.* Albuquerque: Maxwell Museum of Anthropology and University of New Mexico Press.

———. 1983. *Those Who Came Before.* Tucson: University of Arizona Press.

Muench, David, and Donald G. Pike. 1974. *Anasazi, Ancient People of the Rock.* Palo Alto: American West Publishing Co.

Noble, David Grant. 1981. *Ancient Ruins of the Southwest: An Archaeological Guide.* Flagstaff: Northland Press.

Schaafsma, Polly. 1980. *Indian Rock Art of the Southwest.* Albuquerque: University of New Mexico Press.

Tanner, Clara Lee. 1976. *Prehistoric Southwestern Craft Arts.* Tucson: University of Arizona Press.

Weaver, Donald E., Jr. 1984. *Images on Stone.* Flagstaff: Museum of Northern Arizona.

HISTORIC AND CONTEMPORARY SOUTHWEST

Basso, Keith. 1971. Apachean Culture, History and Ethnology. *Anthropological Papers of the University of Arizona* 21.

Downs, James F. 1972. *The Navajo.* New York: Holt, Rinehart & Winston, Inc.

Dozier, Edward P. 1970. *The Pueblo Indians of North America.* New York: Holt, Rinehart & Winston.

Dutton, Bertha P. 1975. *Indians of the American Southwest.* Englewood Cliffs, NJ: Prentice-Hall.

———. 1976. *The Pueblos.* Englewood Cliffs, NJ: Prentice-Hall, Inc.

Ellis, Richard N., ed. 1971. *New Mexico Past and Present: A Historical Reader.* Albuquerque: University of New Mexico Press.

Ezell, Paul H. 1961. Hispanic Acculturation of the Gila River Pimas. *Memoirs of the American Anthropological Association* 90. Menasha, Wisconsin.

Fox, Nancy. 1978. *Pueblo Weaving and Textile Arts.* Santa Fe: Museum of New Mexico Press.

Goodman, James M. 1982. *The Navajo Atlas—Environments, Resources, People and History of the Dine Bikeyah.* Norman: University of Oklahoma Press.

Iverson, Peter. 1981. *The Navajo Nation.* Albuquerque: University of New Mexico Press.

James, Harry C. 1974. *Pages From Hopi History.* Tucson: University of Arizona Press.

Kammer, Jerry. 1980. *The Second Long Walk: The Navajo-Hopi Land Dispute.* Albuquerque: University of New Mexico Press.

Kluckhohn, Clyde, W. W. Hill, and Lucy Wales Kluckhohn. 1971. *Navajo Material Culture.* Cambridge: Belknap Press of Harvard University Press.

Kluckhohn, Richard, and Lucy H. Wales. 1974. *The Navaho.* Rev ed. Cambridge: Harvard University Press.

Lange, C. H. 1959. *Cochiti.* Austin: University of Texas Press.

Lavender, David. 1980. *The Southwest.* Albuquerque: University of New Mexico Press.

Leighton, D.C. and J. Adair. 1966. *People of the Middle Place: A Study of the Zuni Indians.* New Haven: Human Relations Area Files.

McNitt, Frank. 1962. *The Indian Traders.* Norman: University of Oklahoma Press.

Minge, Ward Alan. 1976. *Acoma: Pueblo in the Sky.* Albuquerque: University of New Mexico Press.

Ortiz, Alfonso, Volume ed. 1979. *Handbook of North American Indians; The Southwest.* Vols. 9 and 10. Washington, DC: Smithsonian Institution.

Page, Susanne, and Jake Page. 1982. *Hopi.* New York: Abrams.

Sando, Joe. 1976. *The Pueblo Indians.* San Francisco: Indian Historical Press.

Scully, Vincent. 1972. *Pueblo/Mountain, Village, Dance.* New York: Viking Press.

Spicer, Edward H. 1962. *Cycles of Conquest.* Tucson: University of Arizona Press.

———. 1980. *The Yaquis: A Cultural History.* Tucson: University of Arizona Press.

Spier, Leslie. 1978. *Yuman Tribes of the Gila River.* New York: Dover.

Thompson, Laura. 1973. *Culture in Crisis; A Study of the Hopi Indians.* New York: Russell and Russell.

Underhill, Ruth. 1979. *Pueblo Crafts.* Palmer Lake, CO: The Filter Press.

Van Valkenburgh, Richard F. 1974. A Short History of the Navajo People. In *Navajo Indians,* Vol. 3, Clyde Kluckhohn, ed. American Indian Ethnohistory Series: Indians of the Southwest. New York: Garland Publishing, Inc.

Williams, Anita Alvarez de. 1974. *The Cocopah People.* Phoenix: Indian Tribal Series.

Wright, Barton. 1979. *Hopi Material Culture.* Flagstaff: Northland Press.

Yazzie, Ethelou, ed. 1971. *Navajo History.* Chinle, AZ: Navajo Community College Press for the Navajo Curriculum Center, Rough Rock Demonstration School.

Young, Robert W. 1968. *The Role of the Navajo in the Drama of the Southwest.* Gallup, NM: The Gallup Independent.

BASKETRY

DeWald, Terry. 1979. *The Papago Indians and their Basketry.* Tucson: Terry DeWald.

Dobyns, Henry F. 1972. *The Papago People.* Phoenix: Indian Tribal Series.

Dutton, Bertha P. 1976. *Navajos and Apaches: The Athabascan Peoples.* Englewood Cliffs, NJ: Prentice-Hall, Inc.

Euler, Robert C. 1972. *The Paiute People.* Phoenix: Indian Tribal Series.

———. 1979. The Havasupai of the Grand Canyon. *The American West* 16:12–17.

Joseph, Alice, Rosamund Spicer, and Jane Chesky. 1949. *The Desert People: A Study of the Papago Indians.* Chicago: University of Chicago Press.

Kissell, Mary Lois. 1972. *Papago and Pima Basketry.* Glorieta, NM: Rio Grande Press, Inc.

Navajo School of Indian Basketry. 1971. *Indian Basket Weaving.* New York: Dover Publications, Inc.

Robinson, Alambert E. 1954. *The Basket Weavers of Arizona.* Albuquerque: University of New Mexico Press.

Russell, Frank. 1975. *The Pima Indians.* Tucson: University of Arizona Press.

Tanner, Clara Lee. 1983. *Indian Baskets of the Southwest.* Tucson: University of Arizona Press.

Additional suggested readings on other basket making tribes are listed generally under Historic and Contemporary Southwest.

WEAVING

Amsden, Charles Avery. 1949. *Navajo Weaving, Its Technic and History*. Albuquerque: University of New Mexico Press.

Bennett, Noel. 1974. *The Weaver's Pathway: A Clarification of the "Spirit Trail" in Navajo Weaving*. Flagstaff: Northland Press.

Berlant, Anthony, and Mary Hunt Kahlenberg. 1977. *Walk in Beauty: The Navajo and Their Blankets*. Boston: New York Graphic Society.

Brody, J. J. 1976. *Between Traditions*. Iowa City: University of Iowa Museum of Art.

Cerny, Charlene. *Navajo Pictorial Weaving*. 1975. Santa Fe: Museum of New Mexico Foundation.

Elliott, Malinda. 1984. Exploring a Tradition: Navajo Rugs, Classic and Contemporary. *Fiberarts* (May/June): 33–37.

James, H. L. 1979. *Posts and Rugs: The Story of Navajo Rugs and Their Homes*. Globe, AZ: Southwest Parks and Monuments Association.

Kent, Kate Peck. 1983. *Pueblo Indian Textiles: A Living Tradition*. Santa Fe: School of American Research Press.

———. 1985. *Navajo Weaving: Three Centuries of Change*. Santa Fe: School of American Research Press.

Mera, Harry P. 1947. *Navajo Textile Arts*. Santa Fe: Laboratory of Anthropology.

Reichard, Gladys A. 1936. *Navajo Shepherd and Weaver*. New York: J. J. Augustin.

Rodee, Marian. 1977. *Southwestern Weaving*. Albuquerque: University of New Mexico Press.

———. 1981. *Old Navajo Rugs—Their Development from 1900 to 1940*. Albuquerque: University of New Mexico Press.

Trimble, Stephen, ed. 1981. Tension and Harmony: The Navajo Rug. *Plateau* 52(4).

Wheat, Joe Ben. 1979. Rio Grande, Pueblo, and Navajo Weavers: Cross Cultural Influence. In *Spanish Textile Tradition of New Mexico and Colorado*. Edited by Nora Fisher. Santa Fe: Museum of New Mexico Press.

See also various listings on Navajo culture and material culture under Historic and Contemporary Southwest.

POTTERY

Adams, Eleanor B., and Fray Angelico Chavez. 1956. *The Missions of New Mexico, 1776: A Description by Fray Francisco Atanasio Dominguez With Other Contemporary Documents*. Albuquerque: University of New Mexico Press.

Babcock, Barbara A., Guy Monthan, and Doris Monthan. 1986. *The Pueblo Storyteller: Development of a Figurative Ceramic Tradition*. Tucson: University of Arizona Press.

Blair, Mary Ellen, and Laurence Blair. 1986. *Margaret Tafoya: A Tewa Potter's Heritage and Legacy*. West Chester: Schiffer Publishing Ltd.

Bloom, Lansing. 1935. Bourke on the Southwest, VI. *New Mexico Historical Review* 10(4): 271–322.

Bunzel, Ruth. 1929. *The Pueblo Potter: A Study of Creative Imagination in Primitive Art*. New York: Columbia University Press.

Carlson, Roy. L. 1965. Eighteenth-Century Navajo Fortresses of the Gobernador District. *University of Colorado Studies, Series in Anthropology* 10. Boulder.

Chapman, Kenneth M. 1953. The Pottery of Santo Domingo Pueblo: A Detailed Study of Its Decoration. *Memoirs of the Laboratory of Anthropology* 1 (Revision of 1936 edition). Santa Fe.

———. 1970. *The Pottery of San Ildefonso Pueblo*. Supplementary text by Francis H. Harlow. Albuquerque: University of New Mexico Press.

Chapman, Kenneth M., and Bruce T. Ellis. 1951. The Line-Break, Problem Child of Pueblo Pottery. *El Palacio* 58(9):251–289.

Cushing, Frank Hamilton. 1886. A Study of Pueblo Pottery as Illustrative of Zuni Culture Growth. Pp. 467–521 in *4th Annual Report of the Bureau of Ethnology to the Secretary of the Smithsonian Institution 1882–1883*. Washington.

Guthe, Carl E. 1925. Pueblo Pottery Making: A Study at the Village of San Ildefonso. *Papers of the Southwestern Expedition* 2. New Haven: Published for the Department of Archaeology, Phillips Academy, Andover, Massachusetts by Yale University Press.

Hammond, George P., and Agapito Rey, eds. 1966. *The Rediscovery of New Mexico, 1580–1594: The Explorations of Chamuscado, Espejo, Castaño de Sosa, Morlete, and Leyva de Bonilla and Humaña*. Albuquerque: University of New Mexico Press.

Hardin, Margaret Ann. 1985. *Gifts of Mother Earth: Ceramics in the Zuni Tradition*. Phoenix: The Heard Museum.

Harlow, Francis H. 1973. *Matte-Paint Pottery of the Tewa, Keres and Zuni Pueblos*. Santa Fe: Museum of New Mexico.

———. 1977. *Modern Pueblo Pottery, 1880–1960*. Flagstaff: Northland Press.

Hill, W. W. 1982. *An Ethnography of Santa Clara Pueblo, New Mexico*. Charles H. Lange, ed. Albuquerque: University of New Mexico Press.

LeFree, Betty. 1975. *Santa Clara Pottery Today*. Albuquerque: University of New Mexico Press.

Marriott, Alice. 1948. *Maria: The Potter of San Ildefonso*. Norman: University of Oklahoma Press.

Maxwell Museum of Anthropology. 1974. *7 Families in Pueblo Pottery*. Albuquerque: Maxwell Museum of Anthropology, University of New Mexico.

Mera, Harry P. 1939. Style Trends of Pueblo Pottery in the Rio Grande and Little Colorado Cultural Areas from the Sixteenth to the Nineteenth Century. *Memoirs of the Laboratory of Anthropology* 3. Santa Fe.

Montgomery, Ross Gordon, Watson Smith, and John Otis Brew. 1949. Franciscan Awatovi: The Excavation and Conjectural Reconstruction of a 17th-Century Spanish Mission Establishment at a Hopi Indian Town in Northeastern Arizona. *Papers of the Peabody Museum of American Archaeology and Ethnology, Harvard University* 36. Cambridge.

Peterson, Susan. 1977. *The Living Tradition of Maria Martinez*. Tokyo, New York and San Francisco: Kodansha International.

———. 1984. *Lucy M. Lewis: American Indian Potter*. Tokyo, New York and San Francisco: Kodansha International.

Spivey, Richard L. 1979. *Maria*. Flagstaff: Northland Press.

Stevenson, James. 1883. Illustrated Catalogue of the Collections Obtained from the Indians of New Mexico and Arizona in 1879. Pp. 307–422 in *2nd Annual Report of the Bureau of Ethnology to the Secretary of the Smithsonian Institution, 1880–1881*. Washington.

———. 1883a. Illustrated Catalogue of the Collections Obtained from the Indians of New Mexico in 1880. Pp. 423–465 in *2nd Annual Report of the Bureau of Ethnology to the Secretary of the Smithsonian Institution, 1880–1881*. Washington.

———. 1884. Illustrated Catalogue of the Collections Obtained from the Pueblos of Zuni, New Mexico, and Wolpi, Arizona, in 1881. Pp. 511–594 in *3rd Annual Report of the Bureau of Ethnology to the Secretary of the Smithsonian Institution, 1881–1882*. Washington.

Stevenson, Matilda Coxe. 1904. The Zuni Indians: Their Mythology, Esoteric Fraternities, and Ceremonies. Pp. 3–634 in *23rd Annual Report of the Bureau of American Ethnology to the Secretary of the Smithsonian Institution, 1901–1902*. Washington.

Toulouse, Betty. 1977. *Pueblo Pottery of the New Mexico Indians: Ever Constant, Ever Changing*. Santa Fe: Museum of New Mexico Press.

Wade, Edwin, L., and Lea S. McChesney. 1980. *America's Great Lost Expedition: The Thomas Keam Collection of Hopi Pottery from the Second Hemenway Expedition, 1890–1894*. Phoenix: The Heard Museum.

———. 1981. *Historic Hopi Ceramics: The Thomas V. Keam Collection of the Peabody Museum of Archaeology and Ethnology, Harvard University*. Cambridge.

For additional readings on Pueblo culture and material culture, see general listings under Historic and Contemporary Southwest.

Bibliographies

Dobyns, Henry F., and Robert C. Euler. 1980. *Indians of the Southwest: A Critical Bibliography*. Bloomington: University of Indiana Press.

Iverson, Peter. 1976. *The Navajos: A Critical Bibliography*. Bloomington: Indiana University Press.

Laird, W. David. 1977. *Hopi Bibliography*. Tucson: University of Arizona Press.

Melody, Michael E. 1977. *The Apaches: A Critical Bibliography*. Bloomington: Indiana University Press.

Credits

Page 3—Zuni bowl, early 1800s; 7—Anasazi potsherds, Holbrook, Arizona; 11—Anasazi bowls: courtesy San Diego Museum of Man, photos by Carina Schoening. Page 13—Navajo (no. 30708): courtesy Southwest Museum, Los Angeles. Page 14—(*top*) Black-on-white Anasazi seed bowl, courtesy San Diego Museum of Man; (*bottom*) courtesy Norton Allen; photos by Carina Schoening. Page 15—Kiva interior (no. 22505); 16—G. Wharton James photo (no. 30712); 17—A. C. Vroman photo (no. 30703): courtesy Southwest Museum. Page 20—Apache basket; 23—Pueblo III winnowing basket: courtesy San Diego Museum of Man, photos by Carina Schoening. Page 24—Basket weaver (no. 22041); 25—Hopi weaver (no. 30718); 26—Havasupai weaver (no. 30719): courtesy Southwest Museum. Page 27—Willard J. Chamberlain photo, circa 1912; 28—Apache (or Yavapai) basket, photo by Carina Schoening: courtesy San Diego Museum of Man. Page 29—Havasupai basket: private collection, photo by Jerry Jacka. Page 30—Pima basket: courtesy San Diego Museum of Man, photo by Carina Schoening. Pages 32 and 33—Chemehuevi baskets; 34—Pima basket; 36—Anasazi basket: private collection, photos by Jerry Jacka. Page 37—San Juan Paiute basket: courtesy Museum of Northern Arizona, photo by Jerry Jacka. Page 38—Historic Apache polychrome basket: private collection, photo by Jerry Jacka. Pages 39 through 43—Private collection, photos by Jerry Jacka. Pages 44 and 45—Hopi baskets: courtesy Southwest Museum, photos by Carina Schoening. Page 46—Pima olla: courtesy San Diego Museum of Man, photo by Carina Schoening. Page 47—Havasupai basket; 48—Chief blanket: courtesy Southwest Museum, photos by Carina Schoening. Page 51—Navajo manta; 52—Classic Period blankets: courtesy San Diego Museum of Man, photos by Carina Schoening and Gordon Menzie. Page 53—Willard J. Chamberlain photo, circa 1911–1913: courtesy San Diego Museum of Man. Page 54—Juan Hubbell's office (no. 20779): courtesy Southwest Museum. Page 55—A. W. Ericson photo: courtesy San Diego Museum of Man. Pages 56 and 57—Hubbell watercolors: courtesy National Park Service. Page 58—Navajo (no. 30713): courtesy Southwest Museum. Page 62—Courtesy San Diego Museum of Man, photo by Gordon Menzie. Page 63—Courtesy Southwest Museum, photo by Carina Schoening. Pages 64 and 65—Courtesy San Diego Museum of Man, photos by Gordon Menzie. Pages 66 through 69—Courtesy Southwest Museum, photos by Carina Schoening. Page 71—Courtesy San Diego Museum of Man, photo by Gordon Menzie. Pages 72 and 73—Courtesy Southwest Museum, photos by Carina Schoening. Page 74—Cochiti storage jar; 75—Zuni bowl: courtesy San Diego Museum of Man, photos by Carina Schoening. Page 78—Willard J. Chamberlain photo: courtesy San Diego Museum of Man. Page 79—Wewha (no. 29921): courtesy Museum of New Mexico. Page 80—Potters (no. 30707); 81—Zuni (no. 22611): courtesy Southwest Museum. Page 82—Zuni "salt" jar: courtesy Pueblo of Zuni, property of Pueblo of Zuni, photo by Heard Museum. Page 83—(*top*) Nampeyo pot: private collection; (*bottom*) Al Qöyawayma pot: private collection; photos by Jerry Jacka. Page 86—Jesse L. Nusbaum photo, 1912 (no. 40814): courtesy Museum of New Mexico. Page 97—Acoma potter (no. 20343): courtesy Southwest Museum. Page 88—Cochiti figurine; height 20 inches (catalog 2256): courtesy Taylor Museum, gift of Alice Bemis Taylor, photo by W. L. Bowers. Page 89—San Ildefonso jar (no. PO-150): courtesy Clark Field Collection, Philbrook Art Center. Page 90—Acoma jar (catalog 20902): courtesy Field Museum of Natural History, photo by Diane Alexander White. Page 91—Zuni water jar, 12¼ × 13¼ inches (catalog 03.132): courtesy The Brooklyn Museum. Page 92—Nampeyo jar: courtesy Southwest Museum, photo by Carina Schoening. Page 93—Santa Ana Polychrome: private collection, photo by Jerry Jacka. Page 94—Zia olla: courtesy Southwest Museum, photo by Carina Schoening. Page 95—Tesuque storage jar (catalog PO-164): courtesy Clark Field Collection, Philbrook Art Center. Page 96—Cochiti storage jar; 97—Martinez bowl; 98—Santa Domingo bowl: courtesy San Diego Museum of Man, photos by Carina Schoening. Page 99—Zia dough bowl, circa 1880–1900, diameter 22 inches (catalog 4357); 100—Zuni dough bowl, circa 1880, diameter 16½ inches (catalog 4377); 101—Santa Clara dough bowl, diameter 22 inches (catalog 351): courtesy Taylor Museum, photos by W. L. Bowers. Page 102—Zuni canteen: courtesy Southwest Museum. Page 103—Zuni drum, 21 inches diameter (catalog 4364): courtesy Taylor Museum, gift of Alice Bemis Taylor.

INDEX